BASEBALL
IN NORFOLK, VIRGINIA

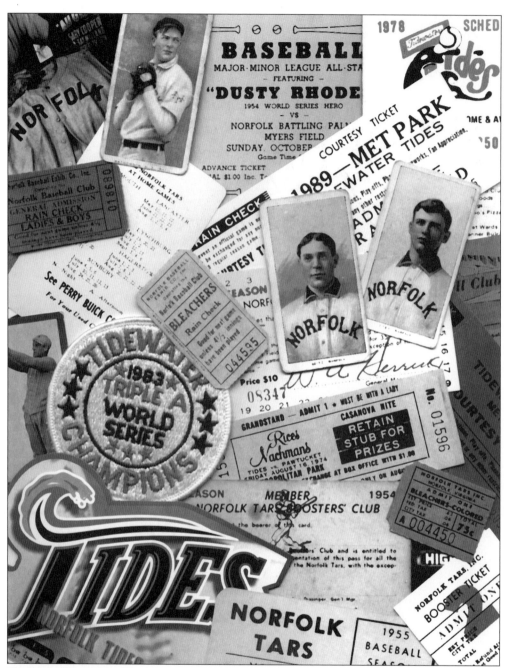

NORFOLK BASEBALL MEMORABILIA AND EPHEMERA. Displayed above is a small sampling of items associated with the history of baseball in Norfolk, Virginia. From worn and creased tobacco cards to tickets and passes pasted into family albums, Norfolk fans collected and cherished mementos of the game over the years. (CSTG.)

Front cover photo courtesy of the *Virginian-Pilot*.
Back cover photo courtesy of Norfolk Public Library.
Background cover photo courtesy of the National Baseball Hall of Fame.

BASEBALL
IN NORFOLK, VIRGINIA

Clay Shampoe and Thomas R. Garrett

ARCADIA

Published by Arcadia Publishing
an imprint of Tempus Publishing Inc.
Charleston SC, Chicago, Portsmouth NH, San Francisco

Printed in Great Britain.

Library of Congress Catalog Card Number: 2002116281

For all general information contact Arcadia Publishing at:
Telephone 843-853-2070
Fax 843-853-0044
E-Mail sales@arcadiapublishing.com
For customer service and orders:
Toll-Free 1-888-313-2665

Visit us on the internet at http://www.arcadiapublishing.com

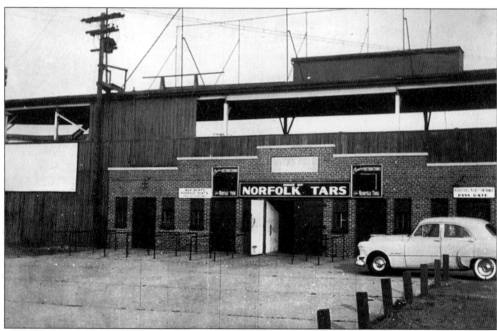

FRONT GATE TO MYERS FIELD, C. 1950. The photograph above shows the exterior front entrance to Myers Field, the playing venue of the Norfolk Tars. Originally christened High Rock Park and often referred to as Tar Park by fans, the stadium served the Tars from 1940 until the summer of 1955. (From the collection of George Tinker.)

CONTENTS

ACKNOWLEDGMENTS

This project was possible due to the cooperation and expertise of many generous and talented individuals. Everyone involved with *Baseball in Norfolk, Virginia* has been more than gracious with their time, knowledge, and support. If anyone that was even remotely supportive during this journey was overlooked by the authors, we offer our thanks here and now.

We would also like to personally thank the following individuals, who went above and beyond in assisting with the book: Alton Brown, former pitcher for the Tars; Allen Gettel, former Tars pitcher; Harry Land, former catcher with the Portsmouth Cubs; Bud Metheny, former Norfolk Tar; Thomas Burt, former player with the Norfolk Battling Palms; Chic Rebel, *Virginian-Pilot* sports editor; Peggy Haile McPhillips, city historian at the Norfolk Public Library; Robert Hitchings, Norfolk Public Library; Kelle Broome, Arcadia editor; Tim Wiles, Jim Gates, and Bill Burdick at the National Baseball Hall of Fame Library in Cooperstown; Gordon Calhoun, *Daybook* editor with the Hampton Roads Naval Museum; Dave Rosenfield, general manager of the Norfolk Tides; Robin Wentz, director of media relations for the Norfolk Tides; Jeff Eastland; Todd Bolton; Matthew Austin; Bill Mountjoy; and Jim Shampoe.

Clay would like to give special thanks to his wife, Deborah, for her complete and enthusiastic support during this time-consuming project; to his Dad, a die-hard Cleveland Indians fan who continues to worship the ground that "Rapid Robert" Feller walks on; and to his Mother, who was always there with unfaltering encouragement.

Tom would like to give heartfelt thanks to his wife, Carol, and son, Andrew, for their constant encouragement during this project and for sharing his passion for the game of baseball.

In 1980, when author Clay Shampoe moved to Portsmouth, he by chance took up residence next to the veteran sports writer, Abe Goldblatt. The two spent many a Sunday afternoon on Abe's back porch discussing the history of the game in Norfolk and Portsmouth. For hours Abe recalled events of the diamond in a way that brought the past to the present. For more than five decades Abe saw local baseball history unfold in front of him and reported it like no other. Aside from his talents with a typewriter, Abe was an archivist and historian adamant that the large collection of vintage sports photography at the newspaper be preserved and catalogued for future generations. The authors acknowledge that these pages depicting Norfolk's baseball history are an extension of Abe Goldblatt's long and storied life as a respected newspaperman. Abe, if you are looking down from that great press box in the sky, Clay and Tom both hope that this book is worthy in its representation of the great history of baseball in Norfolk, Virginia.

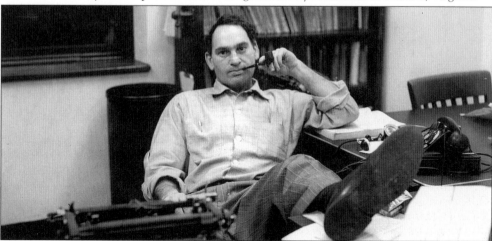

INTRODUCTION

Baseball is said to be a purveyor of memories. Whether they are the recollections of a weathered baseball flying free from a father's hand and snapping the leather pocket of a child's glove, or the sensual explosion of sights and sounds as one enters a stadium for the first time, memories of life with baseball are priceless and cherished.

In this collection of photographic images, *Baseball in Norfolk, Virginia* is replayed like a classic silent movie. For more than a century the city of Norfolk has fielded a professional minor league baseball team. During the ravages of two World Wars, at times of peace and prosperity, as well as through the depths of the Depression there has been one constant in Norfolk, and that is baseball.

The images found within this book were carefully selected to revive forgotten memories and hopefully create new ones. They will allow the reader to imagine what it may have been like to sit upon the rough wooden bleachers of old League Park and marvel at the mastery of a young Christy Mathewson toiling on the mound for the Norfolk Mary Janes. Or experience a warm spring day as Babe Ruth, Lou Gehrig, Bill Dickey, and other legendary Yankees don their pinstripes and partake in an exhibition game at Bain Field. Hear the click of the turnstile and the echoing crack of the bat as you walk through the cool dampness of the first-base ramp and make your way to a box seat perched above the dugout. Admire the speed, power, and agility of Negro League stars Josh Gibson, Buck Leonard, Mule Suttles, and Leon Day as they showcase their talents when segregation ruled baseball. Gaze over the fresh cut turf of Myers Field and read the brightly painted advertisements splashed on the outfield walls as the groundskeeper spreads chalk in a perfect line between third base and home before the Tars take the field. Recall special evenings watching a Tidewater Tides game at intimate Met Park as aircraft rumble overhead and hundreds of feet pounded the metal bleachers in front of the bullpen during a ninth-inning rally. Enjoy a tranquil night game at beautiful Harbor Park on the busy shores of the Elizabeth River watching the Norfolk Tides as the aroma of roasted peanuts, pretzels, and hot dogs waft through the air.

Even the most ardent and devoted Norfolk sports fan may be surprised to learn of the legion of baseball legends that once honed their skills on the grass of our city's sacred diamonds. Big Six . . . Whitey . . . Moose . . . Scooter . . . Yogi. Men that today are known best by their infamous nicknames but were at one time only young, unseasoned ballplayers with nothing more than potential and desire listed on their stat sheets—future baseball immortals that at one time, early in their playing careers, proudly wore a uniform with Norfolk emblazoned on their chests.

Sit down, open a bag of peanuts or Cracker Jacks, and explore the pages of this book and relive the rich photographic history of *Baseball in Norfolk, Virginia.* Enjoy the game.

PHOTOGRAPH LEGEND

VP: From the archives of the *Virginian-Pilot.*
NPL: From the archives of the Norfolk Public Library.
NTBC: From the archives of the Norfolk Tides Baseball Club.
CSTG: From the personal collection of Clay Shampoe and Thomas R. Garrett.
All other photographs individually credited.

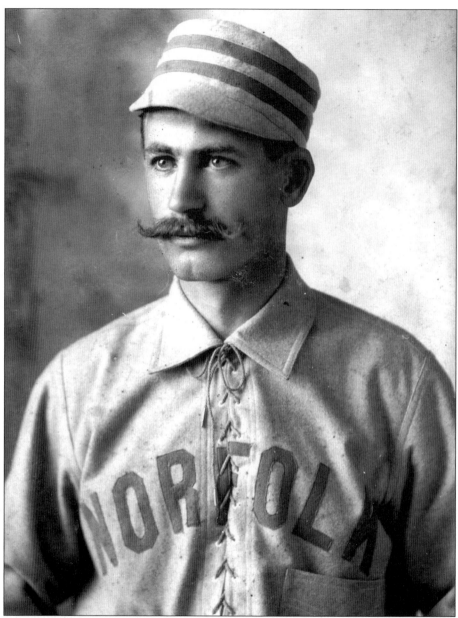

WILLIAM SMITH, PLAYER-MANAGER OF THE NORFOLK JEWELS, 1897. William A. Smith served as manager and right fielder for the Norfolk Jewels of the Atlantic League for the 1897 season. Smith, a league veteran, had served as player-manager for the Lynchburg Hilltoppers in 1895 and again in 1896 when the team was known as the Hill Climbers. An injury kept him out of the lineup during the initial two weeks of the 1897 season and a bout with pneumonia hospitalized him in Richmond following a road trip during the final weeks of the campaign. While adept with the glove in the outfield, his anemic .245 average provided little support for the Jewels as they managed only a fifth-place finish in the league. Despite his lackluster performance as skipper for the 1897 Norfolk nine, he continued to manage for the next 20 years throughout the minor leagues and guided the Southern Association Atlanta Crackers to several league championships. (CSTG.)

ONE

Early Baseball in the Port City of Norfolk

On the afternoon of June 14, 1846, two local teams of men carrying a simple ball and a few crudely shaped bats met on the expansive meadows of the Elysian Fields in Hoboken, New Jersey. They had agreed to partake in a new and novel game that was designed to challenge their ability to strike a thrown ball, run a designated course, and field an elusive sphere made of loosely wrapped fiber. Under the direction and guidance of Mr. Alexander J. Cartwright, a surveyor by profession and local amateur athlete at heart, the two teams purportedly were the first to play the game of "base ball" with explicit convention upon a tailored and regulated field.

From that moment forward, the game of ball and bat gained popularity with both enterprising amateur athletes and the "cranks" that would marvel at the exploits displayed on the diamond. More than two decades later, Harry Wright, a jeweler and leader of a local baseball team from Cincinnati, elevated the game from amateur to professional status. Wright was the first to pay his players for their services as he showcased their talents by staging games and often humiliating any team foolish enough to challenge his Red Stockings to a match.

Several years previous to the formation of Wright's team, there were published reports in the Norfolk papers that the game of baseball had gained acceptance with a number of local amateur organizations. Challenges were arranged throughout the city and Norfolk fans were beginning to take notice. One team, known informally as the "Junipers," made their first appearance on a local diamond in October of 1865 with the city's tabloid reporting "feats of dexterity displayed by the fielders in catching the ball on the fly."

It would not be long after the widespread, documented success of the Cincinnati Baseball Club that enterprising businessmen in Norfolk would begin to invest funds in the new sport. With the first professional leagues in the country established in 1883, Norfolk was only a few years in waiting before the fledgling Eastern League under the directorship of W.C. Seddon admitted the busy Virginia seaport into their fold. The league managed to survive through its 1884 inaugural season; however, instability and turmoil prevailed with a number of franchises disbanding over the course of the year. In 1885, with the Washington Nationals and Richmond Virginians serving as formidable rivals in the league, the Norfolk nine was able to keep afloat for only a portion of the scheduled season and formally withdrew on August 29th, just weeks before the end of the campaign. The city's first experience with organized professional baseball proved to be chaotic, confusing, and unpredictable, with the franchise incapable of establishing a winning record and serving a profit to its investors.

Despite repeated attempts by municipal and business leaders, as well as strident vocal support by the citizenry, Norfolk failed to secure a working relation with an organized league until two out-of-town businessmen, Ted Sullivan and Camden Sommers, convinced enough cities to form the first Virginia League in 1894. The "Oystermen," as the Norfolk team would be labeled, proved to be competitive and often vanquished the likes of the Richmond Colts, the Staunton Hayseeds, the Roanoke Braves,

and the Lynchburg Hill Climbers with ease. While they recorded an impressive record of 66 wins against only 45 losses in 1894, the Oystermen could manage only a second-place finish behind the Petersburg ball club, appropriately named the "Champs." Norfolk would remain a member of the league for the next two seasons and were at times known as the "Clams," "Crabs," or "Crows." Despite the name changes and regular winning records, the success of the team always seemed to fall just short of a pennant for their efforts.

In 1897, Norfolk entered the Atlantic League under the guidance of manager William A. Smith and struggled all season to gain respect in the new league. Despite a strong team of players, Norfolk finished in fifth place, well behind the champion Lancaster Maroons. The following season found the team managed by their owner, W.A. Jewell, and soon became mired in the cellar for the duration of the 1898 campaign.

The Atlantic League carried on without a team from Norfolk for the 1899 season and many of the city's fans felt that any chance to bring organized baseball back would rest on strong financial support. Norfolk was fortunate in that a respected businessman, E.H. Cunningham, continued his attempts to fund a professional team for the upcoming 1900 season. His dual role as owner of the Norfolk team and president of the newly re-formed Virginia League convinced the city and local investors to enter professional baseball once again.

Cunningham enticed John "Phenomenal" Smith to relinquish his role as player-manager of the Portland (Maine) "Phenoms" and establish residence in Norfolk to oversee the newly formed Norfolk "Mary Janes." Smith, a veteran hurler of the American Association, proved to be a successful skipper in Portland as his team captured the 1899 New England League pennant with relative ease. Understandably, he made quite an effort to recruit high-quality players from the league, with many signing contracts and following him South across the Mason-Dixon line into Virginia.

One player of note that caught Smith's eye during the 1899 season was a young Bucknell University pitcher slinging baseballs for the Taunton Herrings during his summer break from studies. Christy Mathewson lost more games than he won during his first year in professional baseball and often went unpaid and unappreciated by the Taunton backers in 1899. Known to possess All-American skills as a drop-kicker within football's college ranks, "Matty" was approached by manager Smith and convinced to sign a contract to pitch for Norfolk during the 1900 season. While the Virginia League was a step-up in status from the lower-level New England League, Matty showed little apprehension during preseason contests and immediately began to dazzle his teammates, manager, fans, and the local press with his mastery on the mound. Interestingly, the city newspaper began to list his name as "Mathews" in the box scores and being the gentleman that he was, never bothered to make a fuss over the misspelling. From late April until mid-July his name would appear along with accolades from the press in that manner.

With opening day falling on April 30, 1900, the Mary Janes found themselves up against their Elizabeth River rivals, the Portsmouth Pirates, at League Park in Norfolk. Norfolk manager Smith started pitcher McCloud on the mound and stayed with him until Mathewson was called off the bench and inserted in the game to protect a slim 8 to 7 lead in the seventh. Matty easily struck out the opposing pitcher on three fastballs that snapped the leather of the catcher's glove with wicked velocity. With the home crowd cheering on the 21-year-old to finish off the side, the Portsmouth batters began to turn the tables on Matty and quickly forced two runners home to take the lead before a third out could be tallied. Mathewson settled down over the final two innings and was able to hold the Pirates scoreless while his teammates pushed two runs over the plate to give him, as well as the Mary Janes, their first victory of the season by a score of 10 to 9. Newspaper accounts the following day raved about his performance stating, "Keep your eye on Mathews; you can't keep it on the ball." The season proved to be Mathewson's most successful in his young career, as exhibited by his 20 wins against only 2 losses. He dominated his opponents by pitching 4 shutouts, 20 complete games, and an impressive no-hitter on June 12, 1900, against the Hampton Crabs.

In a scenario that would be repeated often, the Virginia League began to unravel by mid-season with Petersburg and Richmond bowing out in June and the league formally disbanding after games were completed on July 14th. Matty's last game with Norfolk took place only two days prior to the league's demise, and he earned his 20th victory as the Mary Janes completed the truncated season in first place with an impressive 43–15 record. As Portsmouth and Norfolk officials made hasty plans to play out the

remainder of the season in an effort to keep baseball alive in the area, Mathewson was informed that he had been sold to the New York Giants of the National League. On July 12, 1900 the Virginia League trophy was presented to owner Cunningham, manager Smith, and the Norfolk ballplayers amid much pageantry and fanfare. Meanwhile, Christy Mathewson sat and waited to begin his legendary career at the Polo Grounds in the north Harlem section of Manhattan. His call into action at the league level came quickly as the last-place Giants were anxious to see what their young phenom could do. Mathewson made his first major league game appearance in relief on July 17, 1900 against Brooklyn and as with his Norfolk debut, almost immediately allowed opposing runners to cross the plate. But unlike the victory he recorded on his first day in Norfolk, he was removed by Giants manager George Davis after four innings of ineffective work, giving up three hits and allowing six Superbas to cross the plate. Walking two batters and hitting two others with errant pitches did not help make his first impression with the Giants a good one. It clearly was an inauspicious beginning for the future baseball legend.

After the success of the 1900 season, many Norfolkians were less than pleased that baseball would sidestep the city for over five years. Finally in 1906, the Virginia League was reborn and Norfolk was admitted as a charter member with many familiar rival cities including Portsmouth, Richmond, and Roanoke. The Norfolk team would take the name "Tars" in reference to the old seadogs and sailors that worked the wharves and currents of the Elizabeth River harbor. A former player who once suited up in a Portsmouth Pirates uniform would serve as the team's scrappy second baseman and skipper for the new franchise. Local favorite Win Clark guided the Tars to a second-place finish in 1906 and captured the league batting title with a .303 average in a successful inaugural season in the league.

The following season "Steamboat Bill" Otey, a tall and lanky Norfolk lefthander, led the Virginia League with 22 wins and dominated opponents with 197 strikeouts. A strong Tars pitching staff contributed to an impressive 67 and 48 record as the Tars recaptured the Virginia League pennant for the second time since the turn of the century. Because of his success with Norfolk, Otey found himself in a Pittsburgh Pirates uniform twirling from the mound at Forbes Field as the 1907 season closed down.

With the Tars sinking into the depths of the league over the next two seasons, Win Clark was reinstated as manager to work his magic in the later part of the 1909 season. Despite the dominance of Norfolk outfielder Charles Seitz, who led the league in almost every batting category, the pennant continued to elude the Tars until "Buck" Pressley abandoned Roanoke to serve as the new player-manager for the local nine in 1914. With a potent team composed of sluggers Frank Thrasher and Art Smith, as well as the league's most dominating pitcher, Cliff Markle, Norfolk added its third Virginia League pennant to the flagpole at League Park by finishing 11 games in front of the Richmond Colts.

With the advent of World War I, the 1917 and 1918 seasons were both cut short. The premature termination of the seasons only put the Norfolk fans out of their misery since the Tars were constantly floundering in the Virginia League cellar. The 1920s era of Norfolk baseball is often referred to as the Dave Robertson years. The former National League home-run king and Portsmouth native came to the Tars in 1924 along with Norfolk's seasoned skipper, Win Clark. While Robertson's time in a Tars uniform never resulted in a pennant for the team, he dazzled Norfolk fans on the diamond by capturing league leader honors in a number of offensive categories while splitting his time between manager and outfielder.

By 1928, the Virginia League had dwindled to four teams: Norfolk, Portsmouth, Petersburg, and Richmond. With little in the way of fan support and continued financial concerns, Pres. William G. Bramham announced that the league would fold as of June 3, 1928. It would be the last time that Norfolk would participate as a member of this historic league.

Two agonizing seasons passed in Norfolk again without organized baseball. As the Class A Eastern League began to lose franchises during the 1930 campaign, Norfolk backers took notice and initiated plans to gain membership into the league for the upcoming season. The efforts paid off as both Norfolk and Richmond were voted into the league. Lofty expectations soon evaporated as the season progressed with both teams finishing deep in the second division. Again Norfolk's stalwart ex-skipper, Win Clark, was chosen to lead the Tars but league competition proved fierce as the Northern teams dominated the 1931 season. As witnessed so many times before, the league would announce its demise on July 17,

1932, and again Norfolk would find itself without organized baseball.

Apprehensive fans would only have to forgo a year before a new era of baseball would commence in Norfolk. And what an era it would turn out to be. In a stroke of good fortune in 1934, Norfolk would be named as the new location for a Class B Piedmont League franchise owned by the rich, powerful, and influential New York Yankees. Following the 1933 season, Yankees chairman Jack Ruppert pulled his team out of Durham, and the organization headed to Norfolk to begin the development and refinement of their future baseball stars. Over the next two decades a collection of future Hall-of-Famers and players of notoriety would hone their skills within the walls of Bain Field, High Rock Park, and Myers Field and thus contribute to Norfolk's reign as a powerhouse in the historic Piedmont League.

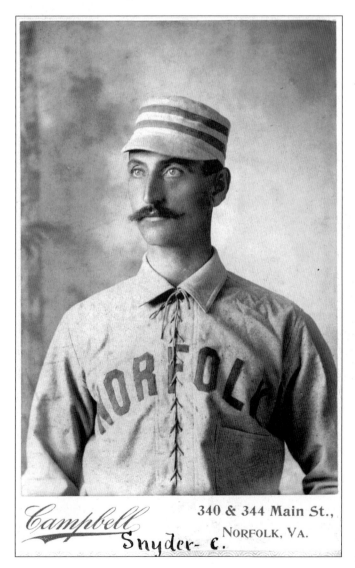

BARNEY SNYDER, NORFOLK CATCHER, 1897. This handsome cabinet shows the classic pose of an early baseball player sitting for his photograph at Campbell's studio on 340 Main Street in Norfolk. Snyder would capture the starting catching position with the Norfolk Jewels only several weeks into the 1897 season by displaying solid defensive skills behind the plate. Over the course of the campaign he would appear in 111 games, score 44 runs, stroke 100 hits, and earn a .249 average for the Jewels. (CSTG.)

DEATH OF A NORFOLK BALLPLAYER, 1897.
Twenty-seven-year-old Jack Gilroy, a veteran
pitcher formerly with the Washington Senators,
would prove to be Norfolk's most effective hurler
during the early weeks of the season, posting a
record of five victories against only one defeat.
Following a game in late May, he complained of
back pain and reportedly almost lost
consciousness several times during the contest.
On June 9th he was diagnosed with appendicitis
and emergency surgery was hastily performed.
Within weeks the team learned that Gilroy had
not been suffering from appendicitis but rather a
kidney abscess. The local paper began a "Gilroy
Fund" to help defray medical expenses and by
July 10th reported that fans had contributed $81,
which was forwarded to the family. Jack Gilroy
died of complications from surgery on August 4,
1897. (From the collection of Charles Snyder.)

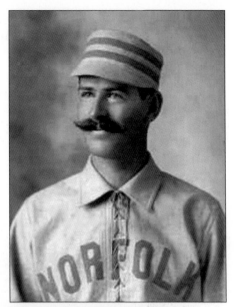

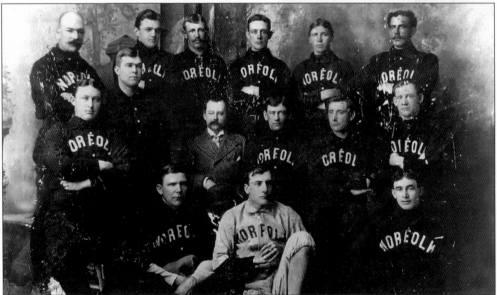

THE NORFOLK BASEBALL TEAM, 1897. The Norfolk Jewels of the Atlantic League met at
Campbell's Photography Studio on Main Street to pose for this vintage team picture. Owner
Broome (in business suit) is surrounded by his players who are watched over by their new
player-manager, William A. Smith (top row, far right) in the photograph. Often referred to as
the Norfolk "Brooms" in the local media, the team was known for their roughneck style of play
and willingness to engage in scrupulous on-field confrontations with visiting opponents. In
an open letter printed in the *Norfolk Virginian*, an out-of-town fan watched a contest at League
Park and stated that "a game of baseball in Norfolk is a thing of horrors and evils. To cope
with the enemy, the visiting team should be armed with crow-bars for bats and have their
pockets filled with small arms." The team was sold in July of 1897 to Mr. E.H. Cunningham,
who would figure prominently in Norfolk's baseball history in the early years of the 20th
century. (National Baseball Hall of Fame.)

Virginia
Atlantic League of Professional Base Ball Clubs

This Agreement, made this *Fourth* day of *October*

Norfolk Base Ball Association

Christy Mathewson of *Lewisburg, Penna.*

party of the second part, **Witnesseth :**

1. Said party of the second part agrees to devote his entire time and services, as a ball player, to said party of the first part during the period of this contract.

2. Said party of the second part agrees to conform to all the rules and regulations now adopted or which may be hereafter adopted by the party of the first part, appertaining to his services aforesaid.

3. Said party of the second part agrees not to render any services as a ball player, during the time of this contract, to any other person, corporation or association, other than the party of the first part, without the written consent of the party of the first part so to do.

4. In consideration of the premises hereinafter set forth the party of the second part hereby agrees that the said party of the first part shall have the option and privilege to renew and continue this contract with all its terms, provisions, conditions and upon the same compensation to said second party for such a period of time in three successive years thereafter, as may be specified in a notice give by said first party to said second party, in person or letter or telegram addressed to his last known place of or pr . the 15th day of September of the current year is contract, and of the current year in which each election of such option and privilege to renew and continu. t'is is made. By the giving of such notice as aforesaid tl s contract shall stand renewed.

In consideration of the foregoing premises 'e party of the first part agrees:—

1. To pay to the said party of the second part the sum of $ *Ninety* per month, to be paid in equal semi-monthly installments, upon the 1st and 15th of every month during the season, which shall commence on *the first day of May* and terminate on the *seventh day of September*, unless the ball team shall be away from home, playing games, in which event the installments falling due shall be paid within the first week after the return home of the said ball team.

2. Said party of the first part agrees to pay the traveling expenses, board and lodging of said party of the second part whenever said party of the second part may be traveling in the services of said party of the first part, and when not so traveling the party of the second part will pay all of his own expenses.

It is hereby mutually agreed by the parties hereto, in consideration of the premises hereinbefore set forth, that should the said party of the second part, at any time or times, or in any manner, fail to comply with the covenants and agreements herein contained or any of them, or with any of the rules and regulations of the party of the first part which are now or may hereafter from time to time be made, or should the said party of the second part at any time or times be intemperate, immoral, careless, indifferent or conduct himself in such a manner, whether on or off the field, as to endanger or prejudice the interest of said party of the first part, or should the party of the second part become ill or otherwise unfit from any cause whatever or prove incompetent in the judgment of the party of the first part, then the said party of the first part hereto shall have the right to discipline, suspend, fine or discharge the said party of the second part in such manner as to it, the said party of the first part, shall seem fit and proper, and the said party of the first part shall be the sole judge as to the sufficiency of the reason for such discipline, suspension, fine or discharge, and in case of fine imposed, it is agreed by said party of the second part that he will pay the same, or that the same may be withheld, as and for liquidated damages.

In order to enable the party of the second part to fit himself for the duties necessary under the terms of this contract, the said party of the first part may require the said party of the second part to report for practice and participate in such exhibition contests as may be arranged by said party of the first part for a period of days prior to the first championship game. The party of the first part to pay the actual expenses of said party of the second part during said period.

It is further agreed that if the said party of the first part should desire the services of the said party of the second part for any period of time after the date mentioned for the expiration of the term mentioned herein, or which may be mentioned in any renewal hereof, said party shall have the right to the same by paying compensation to the said second party for each day at the rate of one-thirtieth (1-30) of the amount herein specified as the monthly salary of said second party.

In Witness Whereof, the said party of the first part has caused these presents to be signed by its officer thereunto duly authorized, and the said second party has affixed his hand and seal on the day and year first above written.

Norfolk Base Ball Association
by John F. Smith, Mgr.
Christy Mathewson [SEAL]

CHRISTY MATHEWSON'S NORFOLK CONTRACT FOR THE 1900 SEASON. On a brisk fall afternoon, the newly appointed manager of the Norfolk baseball team, John "Phenomenal" Smith, found himself in the stands of Bucknell University watching the team's star drop kicker, Christy Mathewson, toil against a powerful University of Pennsylvania team. Smith knew of Mathewson's pitching abilities, as both had served in the Eastern League during the 1899 baseball season. After the gridiron contest was completed, Smith approached the young Mathewson and offered him a contract to pitch for Norfolk. Within a few days Smith had the future Hall-of-Famer officially on his roster. The contract (an old Atlantic League document that Smith altered with a stroke of his pen to indicate that Mathewson's service would be with the newly formed Virginia League) was for a salary of $90 per month. The terms must have been to Mathewson's liking, as he boldly signed the document at the bottom on October 4, 1899. (National Baseball Hall of Fame.)

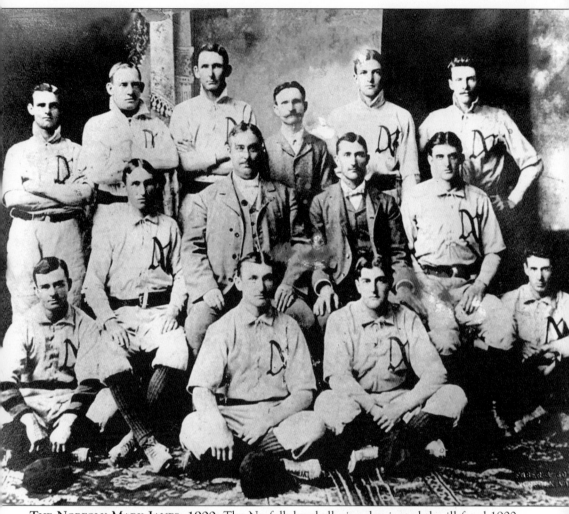

THE NORFOLK MARY JANES, 1900. The Norfolk baseball nine dominated the ill-fated 1900 Virginia League season by quickly outdistancing its only challenger and cross-river rival, the Portsmouth Pirates. In this rare photograph, the Norfolk team poses with Christy Mathewson (top row, second from right), who is taking an unassuming position among his teammates. Manager Smith is sitting at the end of the second row, to the right of the large and imposing figure of Norfolk owner E.H. Cunningham. Surely none of the players or any of the fans that rooted for the young Mathewson during the summer of 1900 could have foreseen his impending impact on the history of baseball. "Matty" would go on to pitch in 17 big league seasons and tally 373 wins while posting an incredible 2.13 career ERA. So impressive were his accomplishments that he was included in the inaugural class of immortals to enter the National Baseball Hall of Fame in 1936. Ty Cobb, Babe Ruth, Walter Johnson, and Honus Wagner would round out the elite five that first entered the hallowed halls of Cooperstown. Sadly, "Matty" was absent from the fabled event, having passed away on October 7, 1925 from tuberculous pneumonia. His resistance to TB was weakened by exposure to mustard gas while serving as an officer in World War I. Norfolk baseball's most famous alumnus, Christy Mathewson spent his final days at Saranac Lake in upstate New York with his devoted wife, Jane. (National Baseball Hall of Fame.)

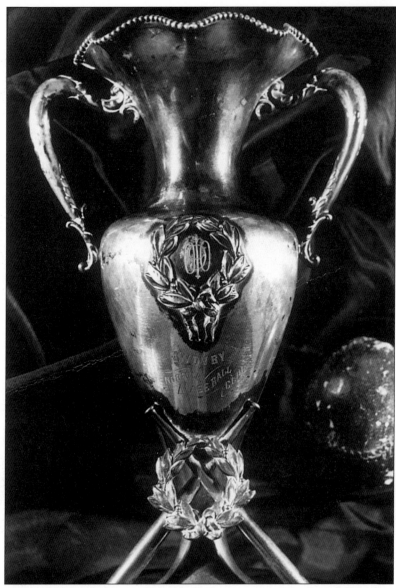

1900 Virginia League Trophy: The Prize Goes to the Norfolk Mary Janes. With the 1900 Virginia League season stretching into its second month, Gale Jewelers of Norfolk commissioned a trophy that would serve as the championship cup for the first-place team at the conclusion of the campaign. The local paper described the trophy in its May 9, 1900 edition: "A beautiful silver trophy is on exhibition in the window of the Gale Jewelry company. The trophy is a handsome cup about 12 inches in height, about 6 inches across, gold lined inside, of plain polished silver with beaded top and bottom. On one side is a silver wreath with a space for engraving. From the base rises a pair of crossed bats separated by a wreath. The trophy is the gift of the Gale's Jewelry and will be presented to the winning team at the close of the season." With Christy Mathewson dominating the league on the mound, the Norfolk Mary Janes finished on top of the league standings after several of the franchises failed to survive the season. Norfolk was awarded the cup in a special pennant raising celebration at League Park on Monday, July 23, 1900. (CSTG.)

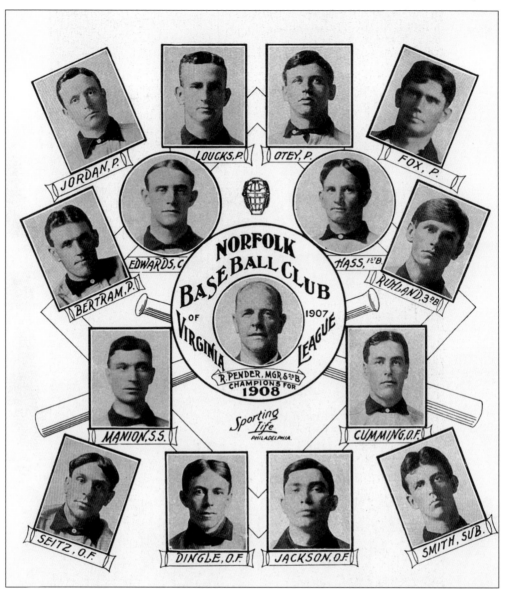

SPORTING LIFE LITHOGRAPH OF THE 1907 VIRGINIA LEAGUE CHAMPIONS. One of the more popular magazines after the turn of the century was a 5-cent rag called *Sporting Life*, a periodical "Devoted To Base Ball, Trap Shooting and General Sports." The April 4, 1908 issue displayed the Norfolk baseball team on its cover and honored them as the reigning champions of the Virginia League following their pennant-winning season of 1907. The run for the pennant would prove to be a tight race as Norfolk, the Lynchburg Shoemakers, and Danville each shared the lead at different times before the Tars reeled in the Red Sox and fled with the title in the final week of the season. Surrounding their playing manager, Robert "Dad" Pender, in the lithograph, the Norfolk team would attribute much of its success to the dominance of "Steamboat Bill" Otey on the mound. The young pitcher compiled 22 wins and 197 strikeouts during the season and garnered league honors in both categories. Near the end of the season his pitching skills attracted the attention of the Pittsburgh Pirates and they quickly signed him to a contract. (CSTG.)

17

NORFOLK BASE BALL CO., INCORPORATED
(TARS)

OPERATING NORFOLK BASE BALL CLUB
VIRGINIA STATE LEAGUE

NORFOLK. VA., Dec. 23/16.

Mr. Frank Garnett,
Williamsburg, Va.
Dear Sir:-

 Am writing to ask if you have decided yet to
play organized ball the coming year. As you know I
must get my club lined up during the winter and would
be pleased to have you.

 If you ever expect to play now is the time for you
to brake in the games, as the majors dont want a man after
he is 24 or 25 years of age.

 I fully believe if you would play with me, I coul
place you in the major league before next season closed
and would assure you my very best efforts in this direction
and help you in every way.

 Please advise me what you will sign for, and hope
you will be willing to begin for a salary in which I
could afford to keep and develop you under, as it is to
your interest more than anyone to start at a small salary
for by so doing you will have a much beer show and br reta-
retained whereby at a haigh salary you would have to
show your worth or be released.

 Thanking you for an early reply, and wishing you
a merry Xmas and happy new year, I remain,
Yours truly,

F. B. Walker

A CONTRACT PROPOSAL TO WILLIAM AND MARY'S CAPTAIN, 1916. After completing his studies at the College of William and Mary, Frank Garnett (second from left) was offered a contract by F.B. Walker, president of the 1916 Norfolk Tars. Walker, showing little in the way of literary proficiency as evidenced by the number of misspelled words in the proposal, made it clear he could develop Garnett's playing skills and move him quickly to the major league level. Despite the offer, Garnett never signed with the Tars, opting instead to work in the family's business after graduation. (From the archives of Kent Garnett.)

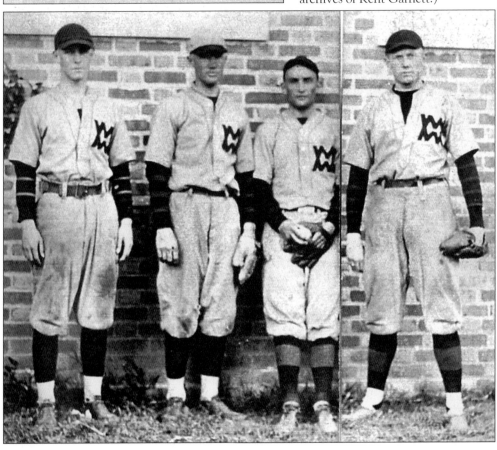

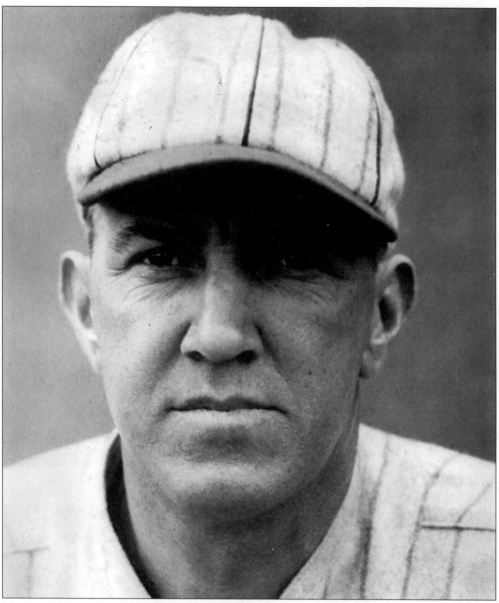

NORFOLK TARS PLAYER/MANAGER DAVE ROBERTSON, 1924–1927, 1931. Portsmouth native Davis Aydelotte Robertson began his major league career in 1912 with the New York Giants and played a total of nine years in the National League until 1922. Used mainly in the outfield, this soft-spoken lefty led the league in home runs in 1916 and 1917 during the dead ball era. In the 1917 World Series, Robertson would set a major league record, hitting .500 over the six-game event, a mark that was unmatched for 36 years. After leaving the majors at the end of the 1922 season, he found work as an outfielder for the 1923 Richmond Colts in the Virginia League. In 1924 he became a Norfolk Tar and contributed 7 home runs, 63 RBIs, and a .314 batting average. From 1925 until 1927 he served as player/manager for the Tars and had a banner year in 1926 as he led the league in batting average (.382) and RBIs (127). He returned to the Tars for 10 games during their first season in the Eastern League in 1931. Dave Robertson died on November 5, 1970, in Virginia Beach, Virginia. (CSTG.)

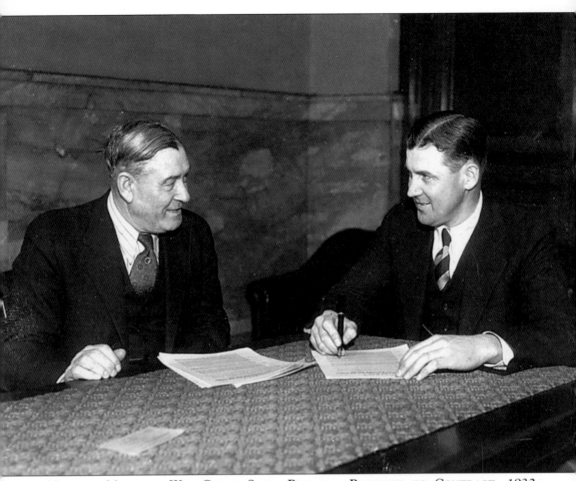

NORFOLK MANAGER WIN CLARK SIGNS PITCHING PROSPECT TO CONTRACT, 1932.
Winfield "Win" Clark (left) is shown offering a new contract to Herb Brett, a veteran hurler for
the Norfolk baseball team during the 1931 Eastern League season. Brett appears eager to put his
name on the contract, which was offered largely in part for his impressive 17–11 record on the
diamond the previous year. Despite his dominance on the mound, Brett accepted a cut in pay
(as did all the players and the manager) to keep baseball afloat in Norfolk for another Eastern
League season. Win Clark, a local baseball icon, served as manager and vice president for the
Tars during their inaugural year in the Eastern League. He returned in 1932 to guide the Tars
from the dugout until poor health caused him to give up his position to Harry Blake. Clark first
played professional baseball with Newport News in 1894, with his best year on the diamond in
1897 with the Louisville Colonels of the National League, when he hit .326 and stole 53 bases.
By the turn of the century he found himself back in the Tidewater area on the roster of the
Portsmouth Pirates as their starting second baseman. Always popular with the fans, he bounced
between Norfolk and Portsmouth serving as player-manager for both cities during the early part
of the century. Clark, known as the "man who had thousands of friends in baseball," served for
21 years as an administrator for the Association of Professional Baseball Players of America, a
benevolent organization that provided support for ballplayers down on their luck. Despite his
diabetes, which resulted in the amputation of both legs, Clark often put his own disabilities
behind him to help other less fortunate players. On April 15, 1959, Win Clark died only four
days after his 84th birthday. (NPL.)

NORFOLK BASEBALL NOTES 1885–1932

◆ In the late winter of 1900 upon arrival in Norfolk, manager "Phenomenal" Smith and owner Cunningham visited Norfolk's League Park to survey the condition of the playing venue for the upcoming season. Both men were surprised to see that most of the wooden slats covering the outfield walls had been removed. When inquiries were made it was discovered that many of the citizens living near the ballpark had torn down the walls and used the slats for firewood during an especially harsh winter.

◆ Christy Mathewson arrived late for preseason training with the Norfolk Mary Janes because of his course work at Bucknell University. When he finally stepped off the train in Norfolk he found that his teammates were preparing to compete in their first exhibition game of the season. Despite his tardiness, Mathewson was able to participate in the game but not as a player. Instead he was selected to umpire the contest.

◆ During the early weeks of the 1900 baseball season, the second baseman for the Portsmouth Pirates, Win Clark, laced a solid single off Christy Mathewson and gave the Norfolk hurler the usual verbal razing about the hit while perched on first base. "Matty" turned calmly to Clark and informed him that he would never get another hit off him again . . . and he never did.

◆ With no professional baseball in Norfolk from 1901 to 1906, the city and its fans supported a semi-pro team called the Norfolk Collegians made up of young ballplayers spending their summer on the diamond during a break from their academic studies.

◆ On July 19, 1908, John Bender, the brother of Philadelphia A's legendary pitcher Chief Bender, was suspended indefinitely by the Columbia Gamecocks of the South Atlantic League for stabbing former Tars manager Win Clark with a knife while on board a steamer taking the team to their next game. Clark would return to the Tars in 1909.

◆ In 1910, Clarence "Red" Munson of Norfolk led the Virginia League in home runs . . . with a grand total of three roundtrippers.

◆ During the 1919 season, Norfolk manager Bill Schwartz was thrown out of a game against the Suffolk Nuts of the Virginia League. Never one to relinquish his duties, the Tars's skipper climbed a tree and directed his players from a perch just outside the ballpark.

◆ In 1913, the Virginia League stolen base leader was Norfolk's fleet-footed center fielder George Kircher. He set an all-time season record with 74 purloined sacks, a feat that was never challenged in the 52-year history of the league.

◆ During the 1921 Virginia League season, Tars third baseman "Rusty" Henges broke his jaw during a fight at League Park. Interestingly, the injury did not come as result of a confrontation with opposing players on the diamond but with a fellow teammate in the Norfolk locker room after the game.

◆ Clay Dailey, a young pitcher with the Louisville Colonels of the American Association, was demoted by manager Joe McCarthy to the Norfolk Tars shortly after spring training in 1921 for ineffectiveness on the mound. Dailey returned to his home in Frankfort, Kentucky and committed suicide on May 28th in a fit of depression due to his failure to make good in baseball.

◆ In 1931, with a new ballclub in the Class A Eastern League for the city, a committee was formed to come up with a new name for the team to replace the well-used moniker "Tars." A contest was held and the public was invited to submit their suggestions. When all entries were counted the name "Tars" proved to be the most popular, just edging out "Cavaliers" and "Pilots." Interestingly, one name that was strongly considered but discarded was "Tides," the name that the franchise would take 31 years later.

◆ Former Norfolk pitcher "Steamboat Bill" Otey died at the age of 44 in 1931. The death certificate states that he contracted syphilis in 1907, the year he pitched for the Tars. His occupation at the time of his death was listed as "auto mechanic."

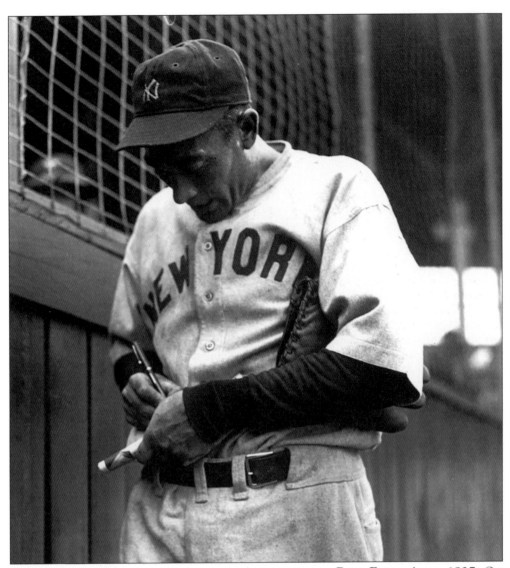

YANKEE GREAT TONY LAZZERI SIGNS AN AUTOGRAPH AT BAIN FIELD, APRIL 1937. On April 15, 1937, the mighty New York Yankees arrived in Norfolk to play their annual exhibition game against the Class B Piedmont League Tars in front of 4,000 enthusiastic fans. The game provided many young Norfolk hopefuls the chance to share the field with their big brother counterparts and gauge their talents against the best in the American League. The Yankees manhandled the Tars 17–7 and sent 8 homeruns over the right field fence at Bain before Norfolk's lefthander Mike DeJan shut down the opposition over the final three innings of the contest. Shown here taking the time to autograph a game program for a lucky fan is Tony Lazzeri. "Poosh 'em Up" Tony would find himself in a New York uniform for the last time in 1937 after first donning pinstripes back in 1926. Considered a solid second baseman and a potent hitter, he was an integral part of the Yankees's famed "Murder's Row," and in 1991 earned induction into the National Baseball Hall of Fame. Following his major league career he spent time in the minor leagues and served as player-manager with the Portsmouth Cubs for the 1942 season. Lazzeri suffered from epilepsy throughout his life and died in 1946, at the age of 42, from a fall during a seizure. (CSTG.)

Two

Major Leaguers in a Minor League City

There are few sporting events that pique the interest of baseball fans more than the appearance of big league stars at the ballpark. The arrival of nationally recognized athletes creates a stir among the citizenry as tickets are purchased and daily schedules altered to allow the fans to sit on the bleachers and be within a baseball's toss of heroes and legends.

Norfolk was fortunate that the northern migration routes of many big league squads leaving Florida's spring training sites often passed through the area. Whether it was via steamer, rail, or road, the major leaguers stopped off and showcased their talents in front of thousands of enthusiastic Norfolk fans. Even before the turn of the century, there is mention in the local papers of such legendary teams as the Boston Beaneaters, New York Giants, and Brooklyn Bridegrooms appearing at Norfolk's League Park.

The most memorable visits by major leaguers came during Norfolk's Piedmont League years from 1934 to 1955. Because of the Tars's affiliation with the New York organization, the Yankees often made Norfolk a stop during the preseason or the dog days of summer. With the city in a fervor over the return of baseball in 1934, the New York Yankees arrived at the Washington Street docks and disembarked with the most popular celebrity of the era, Babe Ruth. It would be Ruth's final year with the Yankees, so many Norfolk fans were privileged to catch a glimpse of the "Sultan of Swat" before he hung up his Yankee pinstripes at the end of the season. The 1934 exhibition will be forever remembered as the contest that nearly ended Lou Gehrig's consecutive game streak when he was beaned by an errant fastball thrown by Tars pitcher Ray White. Over 8,000 Norfolk baseball enthusiasts were on hand to witness the game and retell the events of the day to their children and grandchildren years later.

Some of the games proved to be more colorful than others. One of particular note was staged in 1951, between Leo Durocher's New York Giants and the Cleveland Indians. The Norfolk fans overwhelmed the turnstiles and ended up overflowing onto the field, sitting three and four deep along the first and third base walls. The announced attendance was 9,840 at Myers Field, which had a seating capacity of only 6,000. While Norfolk fans were enjoying the game, a brush fire ignited alongside the exterior outfield wall and began to creep under the bleachers. Smoke soon forced the fans out of the stands and stopped the game as the field was inundated with men, women, and children escaping the spreading blaze. Parked cars so clogged the perimeter of the stadium that fire engines could only access the field by driving on the railroad tracks that backed up to the outfield walls. Play was resumed after 35 minutes with the game ending in a 6–6 tie in the bottom of the ninth. It was one of the most intense and "fiery" major league exhibitions staged in Norfolk's baseball history.

The last arrival of a major league team during the Piedmont years came during the chaotic 1955 season. The Kansas City Athletics visited Myers Field on a cold spring day and drew less than 500 diehard fans as they succumbed to the Tars 5–2. It would be 16 years before another major league club would again set foot on a diamond in Norfolk. In 1970 the New York Mets began a run of annual visits to Norfolk at Met Park for exhibition contests with the Tidewater Tides. With the Norfolk Tides maintaining their affiliation with the New York Mets, the showcase of major league stars continues for the enjoyment of area fans.

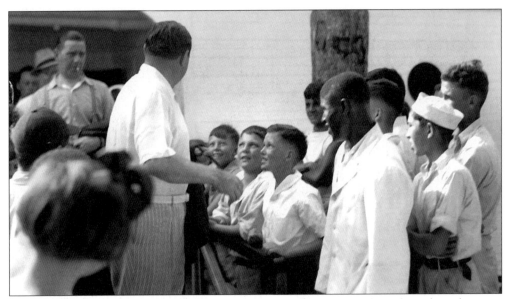

BABE DRAWS A CROWD, 1934. As the steamer carrying the New York Yankees slipped into its mooring at the Washington Street docks, fans of all ages rushed to catch a glimpse of their hero, Babe Ruth. The ever-popular Ruth is shown here surrounded by children trying to get an autograph or handshake before he departs with his teammates for Bain Field and a scheduled exhibition game against the Norfolk Tars. (NPL.)

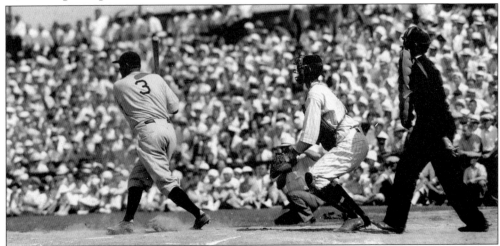

THE BABE CONNECTS AT BAIN, 1934. No one in all of baseball could draw a crowd like George Herman "Babe" Ruth. On June 29, 1934, the New York Yankees made their first appearance at Norfolk's Bain Field. The local fans came through the turnstiles in droves to see the American League legends take on their Tars. The stadium was overflowing with spectators to see the Sultan of Swat, as well as other Yankee greats including Lou Gehrig, Bill Dickey, and Tony Lazzeri. Reports in the papers listed attendance at over 8,000 with many fans seated three and four deep on the field itself, lining the walls from dugouts to outfield fences. Pictured here displaying his classic swing, Ruth connects for his first hit of the day, a single ripped to the outfield. With Lou Gehrig playing in right field for the exhibition, the Babe took over the first baseman's sack. He stroked four hits in four at-bats, driving in two runs as the Yankees edged the Tars 11–9. (CSTG.)

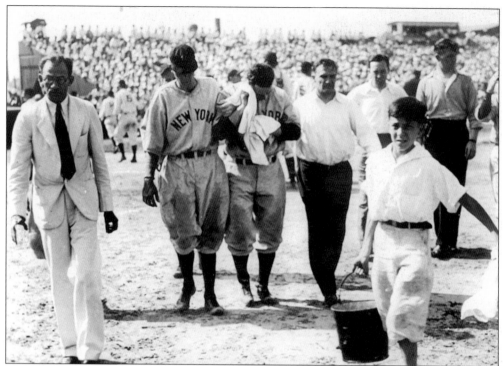

JUNE 29, 1934: THE DAY THE STREAK ALMOST ENDED. The mighty New York Yankees, the new parent club of the Tars, arrived for an exhibition game in Norfolk on June 29, 1934. The Bronx Bombers brought all their legends including Babe Ruth, Tony Lazzeri, Earle Combs, Bill Dickey, and one of the most durable players of all time, first baseman Lou Gehrig. In the summer of 1934, the Iron Horse was in the midst of his historic streak of 2,130 consecutive games. The contest at Bain Field drew a capacity crowd anxious to see what their ace, Norfolk pitcher Ray White, could do against the best of the American League. Gehrig started the game despite continued problems from a recently broken toe. The Yankees took little time in getting to White, with Myril Hoag sending a high arcing home run well beyond Bain's outfield fence on the first pitch of the game. Babe Ruth stepped to the plate and laced a single to the outfield, followed by Gehrig, who quickly cleared the bases with a mammoth shot in the proximity of the Sunlight Cleaners building (located beyond the right field wall). When the Yankees returned in the second inning to continue their pummeling of White, the Norfolk pitcher struck Gehrig above the right eye with a searing fastball as the crowd fell silent. The Iron Horse had completed a run of 1,414 games and it appeared very unlikely that Gehrig would step into the batter's box anytime soon again. In the photograph above, the mighty Lou is helped off the field with assistance from Yankee catcher Bill Dickey as a towel is held to his injury. Manager Joe McCarthy accompanied Gehrig to the hospital and was pleased to announce that x-rays revealed no fracture of the bones around his eye. The swelling from the beaning left the right side of his face grotesquely swollen. Despite his fragile medical condition, the Yankee legend checked himself out of the hospital and accompanied the team to Washington to engage the Senators as scheduled the following day. Amazingly, Gehrig insisted that he be penciled into McCarthy's lineup against the Senators and responded with three triples before the game was rained out. Interestingly, for a period of time Gehrig wore one of Ruth's hats with a makeshift slit along the seam until the swelling subsided and he could slip his own hat over his brow. The Yankee first baseman would continue to play every game until April 30, 1939, when he pulled himself out of the lineup due to complications associated with amyotrophic lateral sclerosis. (CSTG.)

25

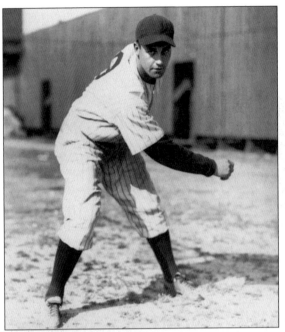

RAY WHITE, TARS PITCHER, 1934. Ray White, the big imposing right-hander for the Norfolk Tars, will always be immortalized as the hurler that beaned Lou Gehrig during the Tars and Yankees exhibition game on June 29, 1934. Gehrig and White reportedly had a mutual dislike for one another, despite the fact both were alumni of New York's Columbia University. Ray White first appeared in a Norfolk uniform in the spring of 1934 and dominated the league with a 17–6 record and a 2.77 ERA. He would later serve as manager for the Tars and be at the helm when they captured the 1938 Piedmont League pennant. (NPL.)

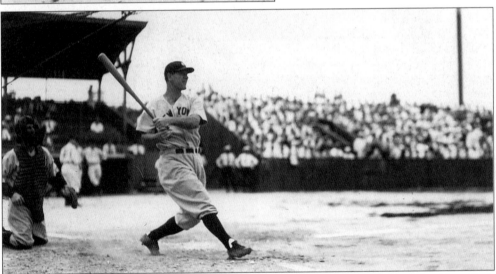

THE REVENGE OF THE IRON HORSE: AUGUST 1, 1935. Lou Gehrig and the New York Yankees returned to Norfolk for an exhibition game against the Tars in early August 1935. It had been little more than a year since Gehrig had suffered a near-catastrophic beaning at the hands of Norfolk pitcher Ray White. The Iron Horse returned for vengeance, and in his quiet, gentlemanly manner destroyed the Tars with his bat. For the day Gehrig would go 4 for 4 at the plate, sending 2 home runs over the Bain Field wall and driving in 5 runs to help support a dominating 12–6 victory. Interestingly, Tars pitcher Ray White did not ascend the mound during the contest, but rather played a few innings of the game at second base and went hitless in his two at-bats. With Babe Ruth no longer wearing New York pinstripes and serving his final year in the majors with the Brooklyn Dodgers, the Norfolk fans were less than enthused with the idea of the Yankees making a visit without the charisma of the Sultan of Swat. Only 3,500 were in attendance to witness the revenge of the Iron Horse. (CSTG.)

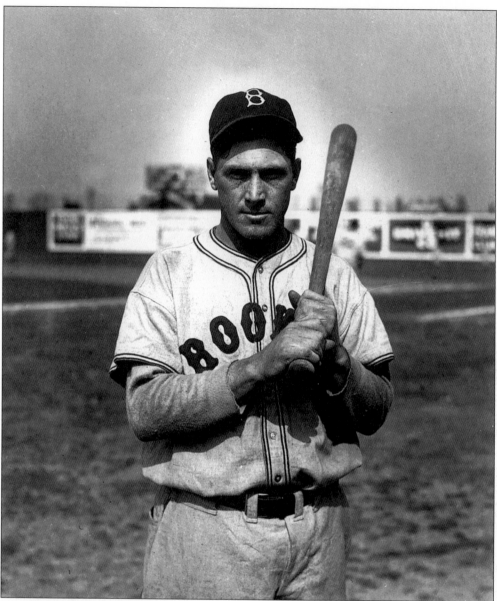

FORMER AND FUTURE TAR BUDDY HASSETT, 1938. Staring menacingly into the lens is Brooklyn Dodger John Aloysius "Buddy" Hassett, in town for an exhibition game at Bain Field during the spring of 1938. As a Norfolk Tar, Hassett was one of the most dangerous hitters in the Piedmont League for the 1934 season, posting an impressive .360 batting average and leading the circuit in doubles (36) and stolen bases (56). His major league playing career began in 1936 with the Dodgers and ended seven years later with the New York Yankees, playing both the outfield and first base. Known for his sharp eye and quick bat, Buddy Hassett made over 3,500 appearances at the plate and struck out only 116 times during his entire big league career. During World War II he turned in his playing uniform and served as a Lieutenant Commander on the aircraft carrier USS *Bennington*. Hassett returned to the Tars in 1947 as their player-manager and moved up through the Yankees minor league system and served as skipper for Binghamton and Newark before his retirement from baseball. (CSTG.)

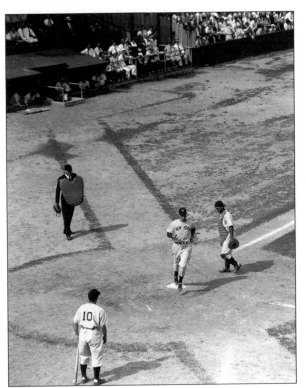

NO HITS FOR JOLTIN' JOE, 1941. On May 26, 1941, the Yankees arrived for an exhibition game in Norfolk and came away with a hard-fought 7–5 victory over the Tars. Few fans at the ballpark that day would have known that the Yankee Clipper, Joe DiMaggio, was just at the beginning of his legendary 56-game hitting streak. Oddly enough, the slugger would go without a hit against Norfolk on this day. Shown here crossing the plate after Bill Dickey's double in the third inning sent him home, DiMaggio could only manage a walk, a run scored, and a pop-fly to center. While the Yankee legend would stroke at least one hit in every game played from May 15 until July 17 of the 1941 season, he came up short at the plate in Norfolk. (NPL.)

YANKEES VISIT TAR PARK, 1947. As one can see from this program sold at Tar Park on April 7, 1947, the Yankees were showcasing their two brightest stars, Joe DiMaggio and Phil Rizzuto. Despite the hype to see the Yankee Clipper in action, the 4,576 fans were instead treated to a hitting barrage by former Norfolk Tar Yogi Berra. Yogi would smash a three-run homer in the first inning and finish the game by going 3 for 6 from the plate with 6 runs batted in. The remaining offensive numbers were supplied by another ex-Tar, Phil Rizzuto, as he went 2 for 3 with a double and drove in 2 runs. The afternoon contest resulted in a humiliating 19–5 defeat for Buddy Hassett's Tars in front of the home crowd. The 1947 exhibition game was the first time the Yankees had appeared in Norfolk since 1942, when they had taken on the Brooklyn Dodgers at High Rock Park. (From the collection of Ron Pomfrey.)

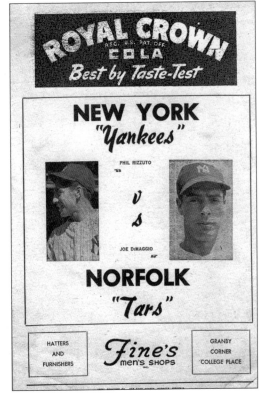

APRIL 7, 1954: NORFOLK TARS ALUMNI RETURN TO MYERS FIELD AS YANKEES. As part of their annual pilgrimage north from spring training, New York brought a slew of former Norfolk Tars to Myers Field for an exhibition game scheduled on April 7, 1954, when this program was purchased. The oldest veteran on the Yankees to formerly wear Tars wool was pitching coach Jim Turner, who once stood atop the mound for Norfolk during the 1928 Virginia League season. Other former Tars included Yogi Berra, Whitey Ford, Phil Rizzuto, Bill "Moose" Skowron, Joe Collins, Tom Gorman, and Bob Grim. The game itself drew 7,906 fans as the Yankees, with Ford on the mound, held the Tars to five hits in a 4–1 uninspired victory. The game was halted after only two pitches when umpire Jimmy Mills was informed that the game had started before the Marine Corps color guard could attend to the flag raising ceremony. Yankee outfielder Mickey Mantle did not participate in the game due to continued rehabilitation following recent knee surgery. (CSTG.)

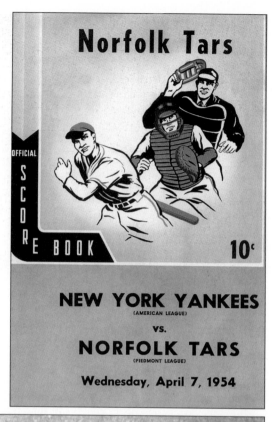

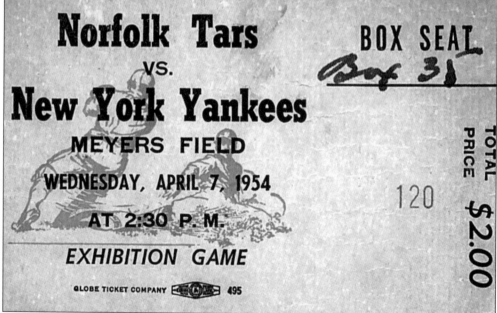

BOX SEAT TICKET, TARS VS. YANKEES, 1954. Pictured is a ticket stub used by one of the 7,906 fans attending the Tars and New York Yankees exhibition game at Myers Field on April 7, 1954. (CSTG.)

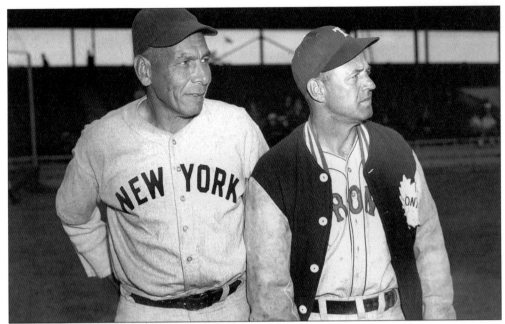

THE CHIEF AND OL' STUBBLEBEARD, 1942. Charles Albert "Chief" Bender (left) and Burleigh "Ol' Stubblebeard" Grimes (right) met at High Rock Park during a three-game series that featured the Norfolk Tars and the Toronto Maple Leafs of the International League. Bender, on assignment by the Yankees, was assisting the Tars's young hurlers in his role as roving pitching instructor. Bender, a full-blooded Chippewa Indian, attended college at Carlisle, the same school as the great Jim Thorpe. In 16 long years on the mound he amassed numerous pitching records, with the majority of his time spent as a member of Connie Mack's Philadelphia Athletics. Burleigh Grimes was given the nickname "Ol' Stubblebeard" during his playing days when he refused to shave before a scheduled start due to the fact that the rosin in his pitching towel would irritate his tender skin. Grimes toiled 19 years in the majors, mostly with the Brooklyn Dodgers, and accumulated 270 victories. Both of these legendary pitchers were inducted into the National Baseball Hall of Fame—Grimes in 1964 and Bender in 1953. (NPL.)

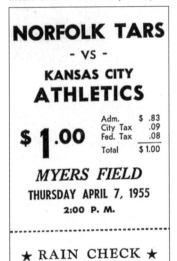

TARS VS. ATHLETICS TICKET, 1955. A cold, blustery wind welcomed Norfolk baseball fans to a preseason exhibition game at Myers Field on Thursday, April 7, 1955. This $1 admission ticket permitted its buyer to sit and shiver while watching the new American League franchise the Kansas City Athletics take on the Norfolk Tars. Despite all logic, the minor league upstarts pummeled the major leaguers 5–2 as only 491 diehard fans cheered them on. Southpaw Roland Adams and right-hander Al Brown teamed up for the Tars and held the Athletics to only four hits during the contest. More appealing competition across the Elizabeth River in Portsmouth may have contributed to the low turn-out at Myers Field, as the Boston Red Sox and Philadelphia Phillies staged an exhibition game at Portsmouth Stadium in front of over 3,500 fans. With Robin Roberts on the mound, the Phillies won the game in ten innings, 4–3. (CSTG.)

Tom Terrific at Met Park.
When the 1970 New York Mets began their annual pilgrimage to Norfolk to play their AAA International League team, the Tidewater Tides, a bevy of Big Apple stars came along for the ride. None was more popular with the local fans or more gracious with autograph requests than pitching legend Tom Seaver. Shown here with young autograph seekers at Norfolk's Met Park, Seaver would put together a storied 20-year major league career that culminated with his induction into the National Baseball Hall of Fame in 1992. (VP.)

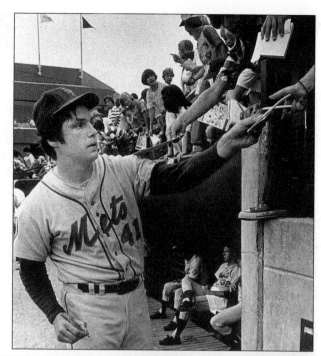

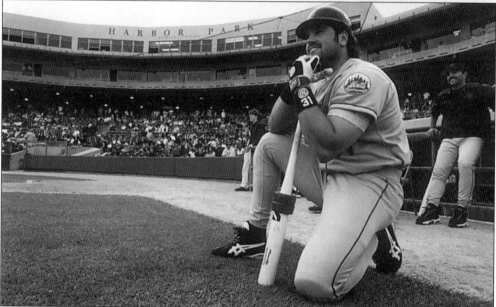

Mike Piazza Waits on Deck at Harbor Park, 2001. Kneeling and waiting for his chance to hit in Norfolk's beautiful Harbor Park is catcher Mike Piazza of the New York Mets. The parent franchise of the Tides arrived in Norfolk to take on their baby brothers and left town with a 2–0 victory. Since putting on a Mets uniform following a trade with the Florida Marlins on May 22, 1998, Piazza continues to add to his personal trophy case with a multitude of league honors. Interestingly, Piazza was the 61st selection of the 62nd round in the June 1988 Free Agent Draft by the Los Angeles Dodgers. Overall, he was the 1,390th pick of 1,433 players drafted that year. (NTBC.)

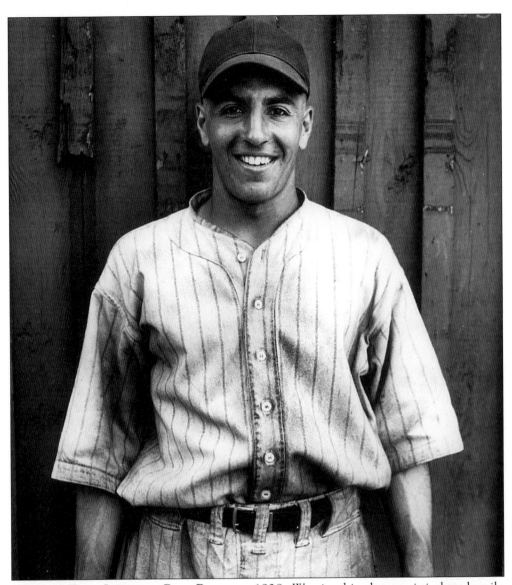

NORFOLK TARS INFIELDER PHIL RIZZUTO, 1938. Wearing his characteristic broad smile and the simple, unadorned pinstripes of the Norfolk Tars, a young 21-year-old Phillip Francis Rizzuto stands in front of the wooden fence at Bain Field for this preseason photograph. The native New Yorker dropped out of high school to pursue a career in professional baseball and found himself in Norfolk for the 1938 season, playing both shortstop and third base. The diminutive and unassuming infielder became a fan favorite during the Tars's 1938 championship season with his sparkling personality and crisp moves, as well as his role in a deadly double play combination alongside second baseman Gerry Priddy. "Scooter" batted an impressive .336, scored 97 runs, batted in 58, stole 26 bases, and sent 9 homers over the fence at Bain during the one year he played for Norfolk. By 1941, he had worked his way through the Yankee organization and would begin a 13-year career as their premier shortstop before entering the broadcast booth. His combination of solid fielding and serving as a superior leadoff man for the powerhouse Yankees earned him a place in baseball's Hall of Fame in Cooperstown. (CSTG.)

THREE

The Norfolk Tars
Powerhouse of the Piedmont

As the hot, humid summer months began to melt the city of Norfolk in 1932, most citizens had more pressing concerns on their minds than baseball. Staggering unemployment, social unrest, and economic uncertainty all proved to be topics of discussion rather than whether or not the Norfolk Tars could work themselves out of the Eastern League second division before the season ended. With dwindling attendance and insurmountable debt, the Norfolk franchise abruptly terminated operations along with the rest of the league on July 17, 1932. Norfolk owners managed to convince the fans to come out to Bain Field for one last game between the Tars and the local Navy Yard team in order to raise enough money for the players to purchase the necessary train or steamer tickets home. With a few dollars in their pockets, the unemployed players hung up their spikes, disposed of their uniforms, and exited Bain Field. With them went organized baseball in the city of Norfolk, and there was little hope that the crack of the bat would ever echo throughout the old stadium on 20th Street.

Despite the poor economic times, citizens of Norfolk knew that the city needed baseball. The young-at-heart wanted to revive old memories and the homesick sailors wanted more diversion than their regular visits to the honky-tonks along the city wharves. Knickered boys continued to anxiously peek through the worn wooden fences of Bain Field hoping to catch a glimpse of anyone preparing the field for play in the spring of 1933. It would be over a year before the gates of the ballpark would be unlocked, the outfield walls painted, and the infield attended to. During the winter of 1933, the powerful New York Yankees decided to relocate their Class B Piedmont League franchise, the Durham Bulls, from central North Carolina to the historic naval city of Norfolk. With the depression in full swing, the money and stability of the Yankee organization was warmly welcomed in Norfolk. Col. Jack Ruppert, owner of the Yankees, and his colleague George Weiss, director of the New York minor league farm system, would begin to funnel an endless stream of talent through Norfolk from 1934 until the early 1950s.

Norfolk's past success in the Virginia and Eastern Leagues was inconsistent at best. With rare championships in 1900, 1907, and 1914, the first 47 years of baseball in Norfolk yielded many disappointing seasons for the faithful fans gathering in old League Park and Bain Field. Not surprisingly, everything would change with the arrival of the Yankee organization. Ruppert and company were not afraid to spend the time and money to develop their future major league stars in Norfolk, Binghamton, and Newark.

After an opening away-game series in which they swept the Richmond Colts, the Tars met the Wilmington Pirates at Bain Field on April 28, 1934 amid fanfare, excitement, and exuberance. With city dignitaries, boy scouts, military bands, and players marching from Commercial Place in downtown Norfolk to the ballpark off of Church Street, the game commenced with a dramatic flag-raising ceremony as both teams lined the outfield wall. Wilmington, in their fire-engine red garb, and Norfolk, in the traditional pinstripes of the Yankees, stood side by side as the team managers raised the flag to symbolically begin a new era of baseball in Norfolk.

While the Tars would come out on the short end of that opening home game, they quickly recovered and captured the Piedmont League pennant and dominated their opposition in post-season

championship play. From the 1934 season until the end of the 1939 campaign, Norfolk would win the league flag three times (in 1934, 1936, and 1938) and upset their playoff foes in 1937 after finishing in second place behind the Asheville Tourists. During the 1930s there was no other team in the Piedmont that would even come close to challenging the Tars for more than a single season.

Former major league catcher Bill Skiff served as manager for the Tars during their first two Piedmont League seasons, but eventually fell out of favor with owner Ruppert as Norfolk stumbled during the 1935 season, finishing in the second division. Johnny Neun, another former major league veteran, took over and immediately brought the crown back to Norfolk in his first season. As the decade closed out, the Yankees placed the leadership of Norfolk into the hands of former Tars pitcher Ray White.

During the early days of Norfolk's Piedmont League experience, the team relied on the powerful swing of left fielder Jim Bryan to annihilate the opposition. Bryan won the Triple Crown and was the league's Most Valuable Player in 1934 as he clubbed 30 home runs, knocked in 144 RBIs, collected 200 hits, and established a .376 batting average. The Tars catcher, Buddy Rosar, showed power at the plate during the 1935 season, with 26 home runs and a nifty .347 batting average. Rosar would take his place behind the plate with the Yankees in 1939, but would remain in Bill Dickey's shadow until finally making a name for himself with Connie Mack's Philadelphia Athletics in the mid-1940s.

A flock of talent surfaced in Norfolk uniforms for the 1937 season. Established and future major league prospects such as Tommy Holmes, Mike DeJan, Ed Levy, Norm Branch, Myron Hayworth, Pete Suder, Hiram Bithron, Nick Strincevich, and Mickey Witek contributed to Norfolk's postseason dominance over both Richmond and Portsmouth as they wrestled the Shaughnessy Trophy from their foes.

Before taking over as manager for the Tars in 1938, Ray White was a heralded Yankee pitching prospect that put up good numbers in the organization but never donned New York pinstripes in the majors. A huge favorite of local fans, White proved to be a masterful manager as he guided the 1938 Tars back to the Piedmont League throne. Often considered by many as the best team in the history of Norfolk baseball, the Tars's lineup boasted many future Yankee legends, including the diminutive Phil Rizzuto. The smoothest double play combination in all minor league baseball could be found on the infield dirt of Bain Field during the summer of 1938. With Rizzuto at shortstop and future Yankee Gerry Priddy at second, the Tars had a team that marveled fans and foes with glove as well as bat. Homegrown hero Bud Metheny topped the league in homeruns and former House of David expatriate Don Hendrickson's 21 victories from the mound led the Tars to an impressive 84–52 season record.

As the country's economic woes began to wane and talk focused on the impending war in Europe, the Norfolk Tars began to prepare for the upcoming decade with optimism, confidence, and élan. While the Yankees would continue to support their Piedmont League franchise with promising players, many young men earmarked for the major leagues would find themselves in Norfolk during the early 1940s for another reason: preparing for the war effort.

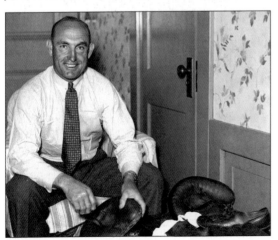

BILL SKIFF ARRIVES IN NORFOLK, 1934. New Tars manager Bill Skiff is shown unpacking his equipment as he settles into a Norfolk hotel room in the spring of 1934. The former Durham Bulls skipper served as a reserve catcher with the Pittsburgh Pirates in 1921 and later with the new York Yankees in 1926. (NPL.)

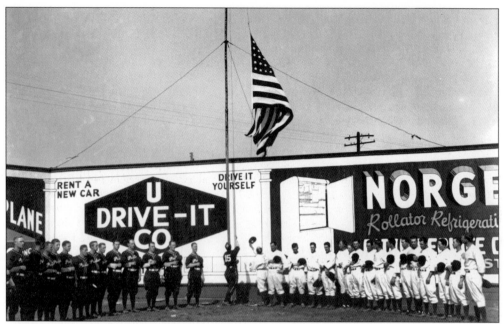

OPENING DAY AT NORFOLK'S BAIN FIELD, 1934. Norfolk fans were counting the days from the moment when the Tars last took the field in July 1932 until this bright spring day of April 28, 1934, when the team played their first home game as a member of the Piedmont League. At exactly 3:45 in the afternoon, Tars manager Bill Skiff and Wilmington skipper Blackie Carter hoisted Old Glory up the flagpole as the two teams saluted with their caps firmly planted over their hearts. The crowd of 4,026 roared their approval and thus began Norfolk's long and impressive run of dominance in the Piedmont League. Despite a demoralizing 16–8 loss to the Pirates that day, the Tars would win the Piedmont pennant with an impressive 89–49 record and defeat the Charlotte Hornets 4 games to 2 in the league playoffs. The championship would be the first for Norfolk since capturing the Virginia League flag back in 1914. (NPL.)

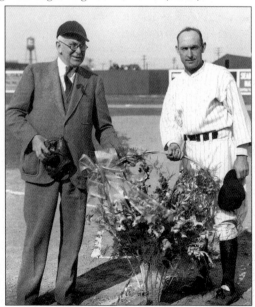

FLOWERS FOR THE NORFOLK MANAGER, 1934. Part of the opening day festivities at Bain Field on April 28th included the presentation of a floral spray to the new Norfolk skipper, Bill Skiff (right). Pictured here along with Skiff is Norfolk City Manager Tommy Thompson, who also had the honor of throwing out the ceremonial first pitch. Bill Skiff was manager with the Durham Bulls when Yankee owner Jack Ruppert pulled the franchise from North Carolina and relocated the team to Norfolk for the 1934 Piedmont League season. Skiff led the Tars to the league championship in 1934 but ran on hard times during the 1935 season, only guiding Norfolk to a disappointing second division finish. (NPL.)

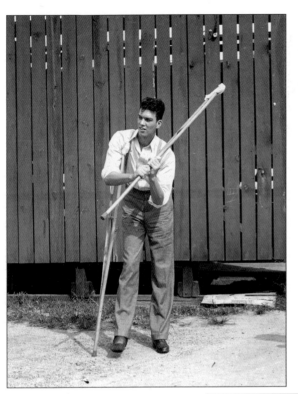

SKEETS SWINGS AWAY, 1934.
Twenty-year-old George "Skeets" Dickey, the rookie catcher for the 1934 Tars, shows he still has the correct batting stance even though he must use a crutch instead of a bat. Skeets broke his leg during the second inning of a game played against the Charlotte Hornets at Bain Field on August 1, 1934. After ringing up a double, Dickey was driven home and caught his spikes sliding across the plate, cracking his leg above the ankle. The young Tars catcher was following in the footsteps of his older brother, Bill Dickey, the star major league catcher with the New York Yankees. The local paper described Skeets as quite a ladies' man with numerous female visitors reportedly visiting him as he recuperated at Norfolk's Sarah Leigh Memorial Hospital in Ghent. (NPL.)

CECIL SPITTLER, 1934. Norfolk Tars hurler Cecil Spittler, shown in his classic windup on the grass at Bain Field, was discovered by New York Yankee pitching coach Russ Van Atta and signed to a contract for the 1934 season. Spittler was touted as a promising rookie hurler and would earn a spot on the Tars's pitching staff by opening day. Spittler proved to be effective during the 1934 season as he posted a 14–10 record and served up an impressive no-hitter thrown against the Richmond Colts on July 24th. Despite his promising start with the Tars in his first year of professional baseball, Cecil Spittler never made it to the major leagues. (NPL.)

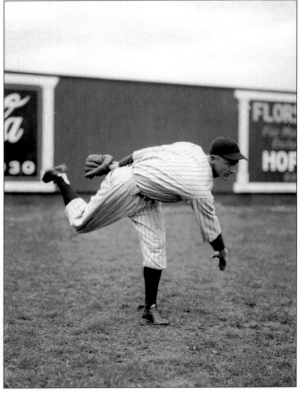

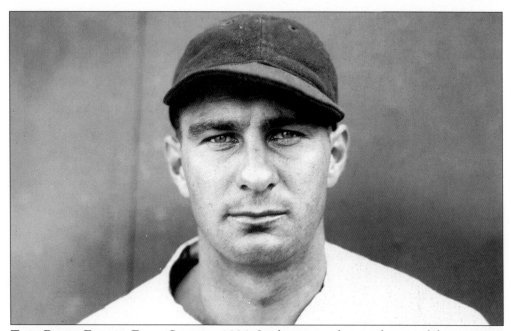

Tars Right Fielder Eddie Sawyer, 1934. Looking intently into the eye of the camera is Norfolk Tars right fielder Eddie Sawyer. During the 1934 season he was credited with a .361 average while knocking in 74 basemen and slugging 11 homers out of Piedmont League parks. With Dan Hall (24 home runs), Jim Bryan (Triple Crown winner with 30 home runs), and Sawyer roaming the far reaches of Bain Field, manager Bill Skiff found himself with one of the most potent collections of outfielders in Piedmont League history. (NPL.)

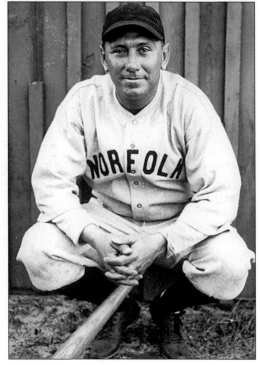

Johnny Neun, 1936–1937. Pictured here in front of the wooden fence at Bain Field in 1936, John Henry Neun was selected by Jack Ruppert's Yankee organization as the Tars's new manager to improve on the team's fourth-place finish in 1935. Neun would lead the Tars past the Durham Bulls late in the season and walk away with the pennant by 13 1/2 games with a 93–50 record. On the field he anchored the first-base position for the Tars and excelled with the bat, posting a .316 average. For his leadership in guiding Norfolk to the pennant, Neun was named Piedmont League Manager of the Year in 1936. Neun broke into major league baseball as an infielder with the Detroit Tigers in 1925, and on May 31, 1927 was credited with performing one of baseball's rarest of defensive plays: the unassisted triple play. (CSTG.)

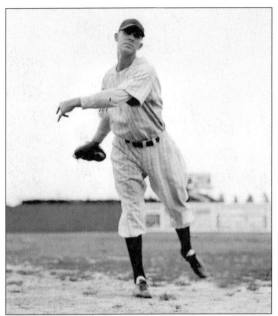

"LEFTY" YOCKE NORFOLK ACE, 1936.
No other pitcher in the Piedmont League could boast of a more gaudy record during the 1936 season than Norfolk's southpaw, Bill Yocke. When the campaign came to an end, Yocke had accumulated a total of 18 wins against a single loss and led the Tars to their second Piedmont pennant since entering the league in 1934. After posting his impressive record he was quickly elevated through the New York minor league system but would never recapture the dominance he displayed with the Tars in 1936. "Lefty" returned to the Tars for the 1938 season and immediately ran off four consecutive victories before settling down to a 7–3 record. (NPL.)

MANAGER JOHNNY NEUN DOLES OUT THE CASH, 1936. With the Norfolk Tars finishing the regular season well ahead of their nearest competitor, it was not a surprise that they would run rampant over their opponents in the 1936 Shaughnessy Playoffs. In the postseason, Norfolk swept the Richmond Colts in three quick games and continued their unbeaten streak against the Durham Bulls to close out the playoffs with a perfect 6–0 record. Here at a special meeting at Bain Field in September 1936, Norfolk skipper Johnny Neun shows his players the wad of bills that will soon be filling their pockets before he sends them home for the winter months. (NPL.)

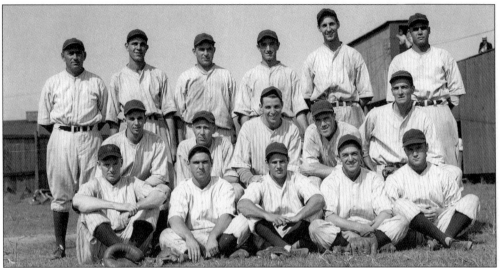

1937 NORFOLK TARS. Posing outside the walls of Bain Field are Johnny Neun's 1937 Norfolk Tars. The team would end the season in second place only 4 1/2 games behind the Asheville Tourists. The Tars dominated postseason play and captured the Shaughnessy Trophy by sweeping the Portsmouth Cubs in the finals. Neun is standing in the back row far left. Six Tars players batted at or above .300 for the 1937 season: Archie Allen (.354); Tommy Holmes (.320); Mickey Witek (.320); Ed Levy (.313); Mike DeJan (.301); and Pete Suder (.300). Hiram Bithorn, with his 1.47 ERA and 10–1 record, dominated the pitching staff while Norm Branch led the team with 14 wins. Allen, Holmes, Witek, and Bithorn were selected to serve on the 1937 Piedmont League All-Star team. (NPL.)

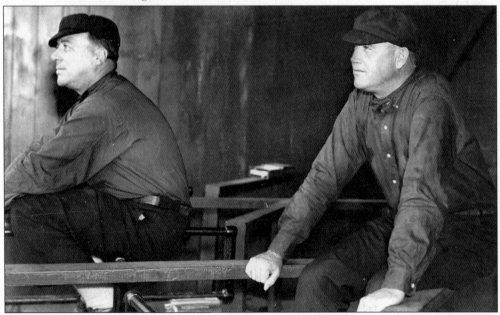

WAITING FOR THE RAIN TO ABATE. Two Piedmont League umpires sit atop the turnstiles at Bain Field watching the rain cascade down on 20th Street outside the stadium. It would be their decision to call the match a rain-out and inform the fans huddled under the grandstands that there would be no game. (NPL.)

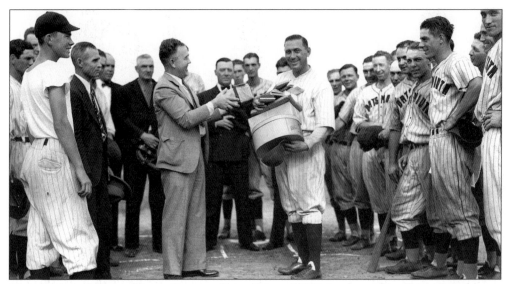

CELEBRATING JOHNNY NEUN DAY AT BAIN FIELD, 1937. In the midst of the Shaughnessy playoff finals against the Portsmouth Cubs in early September 1937, the fans of Norfolk set aside time before a game to honor Tars manager Johnny Neun. Pictured here at home plate, Neun receives a variety of gifts from local merchants, the media, and fans at Bain Field. As the opposing players from Portsmouth look on with envy, Dr. J.P. Bradshaw, reigning president of the Lion's Club, heaps mementos and accolades into the arms of Neun. The Tars manager had every right to smile, as he would guide Norfolk to a three-game sweep over the Cubs and capture the playoff trophy for the second year in a row. For his accomplishments, Johnny Neun would be named Piedmont League Manager of the Year for the second straight season. (NPL.)

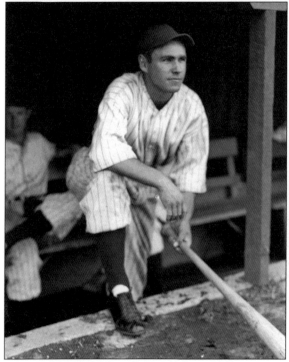

TOMMY HOLMES, 1937. Looking pensively out over the grass of Bain Field from the Norfolk dugout, Tommy Holmes proved to be one of several heavy hitters that manager Johnny Neun could count on to clear the bases for the Tars in 1937. Holmes developed into a dominating slugger for Norfolk during their championship season and crushed 25 home runs while knocking in 111 runs. He led the team at the plate with a .320 average, and his miserly 26 strikeouts proved he had an eye for the right pitch. Holmes would become legendary for his hatred in striking out at the plate. When he reached the big leagues as a Boston Brave, he continued to avoid the third strike and posted only 122 whiffs at the hands of opposing pitchers over an 11-year league career. (CSTG.)

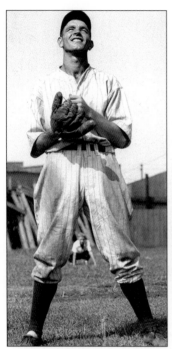
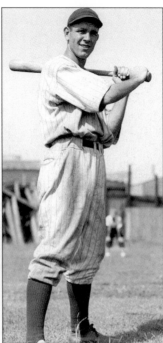
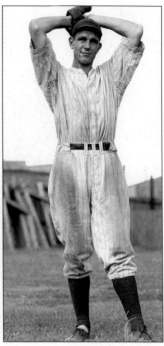

A TRIPLE THREAT FOR THE NORFOLK TARS: MIKE DEJAN, 1937. Many players of the time served in a variety of positions on the field, but few matched the multi-level excellence of Norfolk's 22-year-old southpaw Mike DeJan. Reporting as a pitcher to manager Johnny Neun during spring training, DeJan's bat impressed his skipper and he quickly found himself playing right field for the Tars. The following statistics speak for themselves: 133 game appearances; .301 batting average; 13 home runs; 143 hits; and 64 RBIs. From the mound he was given the ball by Neun in only four games, since the Tars's pitching squad was both deep and effective. Shown in the photographs above, Mike DeJan displays his expertise in fielding, batting, and pitching. His major league career was restricted to only 12 games with the Cincinnati Reds during the 1940 season. (NPL.)

POSTSEASON WINNING STREAK ON HOLD DUE TO RAIN, 1937. The Norfolk Tars continued their dominance during the playoffs and had already taken two straight games from the Richmond Colts when their winning streak was suspended—not by the opposition but instead by rain. Pictured here in their civilian clothes, the Tars check precipitation levels before the game was called off and the players were sent home for the afternoon. (NPL.)

LOOKING AFTER RIZZUTO'S THROWING WING, 1938. During the heat of the 1938 pennant race, Norfolk Tars shortstop Phil Rizzuto injured his throwing arm during a double play attempt at Rocky Mount. Pictured here is Jimmy Ewell, the Norfolk trainer who does not look much older than "Scooter," as he checks for indications that Rizzuto's healing is on track. Ewell served as batboy for the Tars beginning with the 1934 season and was so well-liked in the organization that he was appointed trainer for the team in 1938. He served in that capacity for several years. (NPL.)

RAY WHITE DAY, 1938. The Tars set aside August 17, 1938 to honor their manager, Ray White, at the ballpark. Before the scheduled contest with the Charlotte Hornets, the local Lion's Club and Norfolk fans heaped accolades and gifts on the Tars skipper. Pictured here at the microphone, Ray White thanks the Bain Field crowd as his family and community officials look on. With baby strollers and other household items as part of the parade of gifts, the manager and his wife must have been setting up house and expecting a new addition to their family. (NPL.)

A Trio of Tars Aces, 1938.
The Norfolk Tars captured the 1938 Piedmont League pennant with a solid combination of great hitting, pitching, and defense. In this photograph, Don Hendrickson is showing fellow hurlers Joe Yenoskey (left) and Earl Schamp (center) the grip he used to baffle opposing batters throughout the season. While Yenoskey posted a 10–5 record and Schamp notched an impressive 18 victories against 10 losses, it was Hendrickson's 21 wins that dominated the Piedmont. Hendrickson played professionally for the legendary House of David baseball team before signing with the Tars. He must have looked quite different with untrimmed locks and flowing beard, which were trademarks of this unique barnstorming team. Of the three Tars hurlers in this photograph, only Hendrickson made it to the majors, serving two seasons with the Boston Braves in 1945 and 1946. (NPL.)

The Scout and the Skipper, 1938. Tars manager Ray White was one of the first to purchase two tickets for the upcoming benefit game at Bain Field between the local American Legion squad and the semi-pro Norfolk Orioles. Selling tickets is major league scouting legend Harry Postove (left) who was credited with discovering and signing much of the local baseball talent throughout the Tidewater area. Postove was chairman of the Norfolk American Legion baseball committee and a lifelong advocate for baseball in Norfolk. (NPL.)

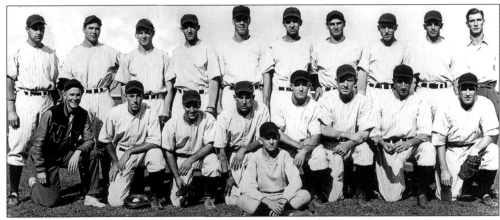

THE NORFOLK TARS: PIEDMONT LEAGUE PENNANT WINNERS FOR 1938. After backing into the Piedmont League pennant on the last day of the season, Ray White's Norfolk Tars unraveled during the Shaughnessy Playoffs and were quickly eliminated in the first round by the Rocky Mount Red Sox. Despite their failure to capture the playoff trophy, many minor league historians feel that the 1938 Tars were one of the best teams to ever take the field in the history of the Piedmont League. Their roster showcased many future major leaguers. In the back row from left to right are Ray White, Blackie Caldwell, Gerry Priddy, Paul Badgett, Jack Graham, Earl Schamp, Joe Yenosky, Jack Crosswhite, Charlie Fallon, and Ken Manning. In the front row from left to right are Jimmy Ewell (trainer), Bob Baker, Phil Rizzuto, Leon Hendrickson, Bud Metheny, Bill Yocke, Milo Candini, and James Calleran. Seated in front is batboy Bernard Hayes. (National Baseball Hall of Fame.)

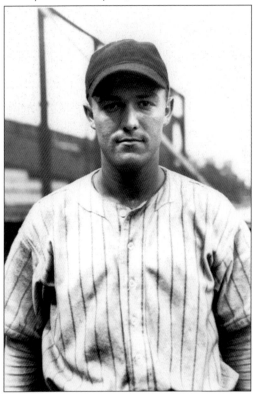

A NORFOLK SPORTS ICON: BUD METHENY, NORFOLK TARS RIGHTFIELDER, 1938. Arthur Beauregard Metheny, nicknamed "Bud" by his teammates, first donned a Norfolk uniform for the 1938 season. His slick fielding and heavy hitting were important elements in the Tars's success, as he slugged 21 home runs in 89 games and established a .338 batting average for the year. Metheny would work his way through the Yankee minor league system and first appeared with the big league club in 1943 and served as New York's starting right fielder through the war years. Following his major league career, he returned to play for the Portsmouth Cubs and the Newport News Dodgers and continued to manage throughout the minor leagues. Bud is renowned throughout the Hampton Roads area for his many successful years as the baseball coach for the Old Dominion University Monarchs. The stadium on the ODU campus is named in his honor. (NPL.)

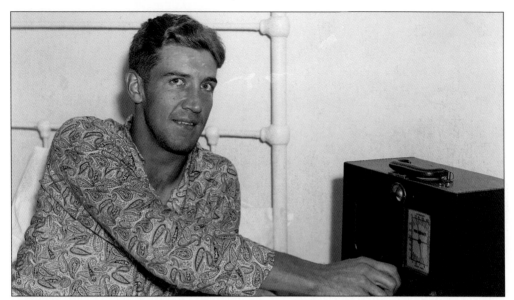

KEN MANNING, NORFOLK FIRST BASEMAN TUNING INTO THE TARS, 1938. Never one to miss out on what was going on with his teammates, Norfolk Tars first sacker Ken Manning adjusts his radio and listens to the game. Manning was recuperating at Sarah Leigh Memorial Hospital from a mild concussion he received during a recent game at Bain Field against the Richmond Colts. He fully recovered and joined the rest of the Tars for the remainder of the season. (NPL.)

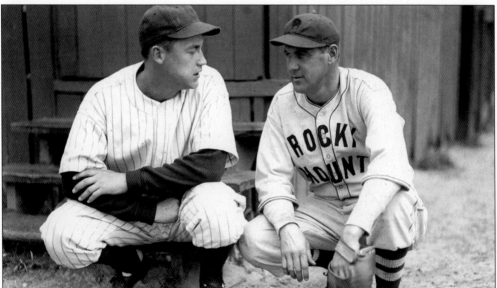

RIVAL MANAGERS TALK IT OVER, 1938. Ray White, Norfolk Tars skipper, and Herb Brett, manager of the Rocky Mount Red Sox, chew the fat in the middle of a rain delay during the 1938 Shaughnessy Playoffs for the Piedmont League postseason trophy. Brett and his Rocky Mount players got the best of the Tars and eliminated them 3 games to 1 before losing to the Charlotte Hornets in the postseason final round. Seven years earlier, the Rocky Mount manager had pitched for the 1931 Norfolk Tars during their first year in the ill-fated Eastern League. (NPL.)

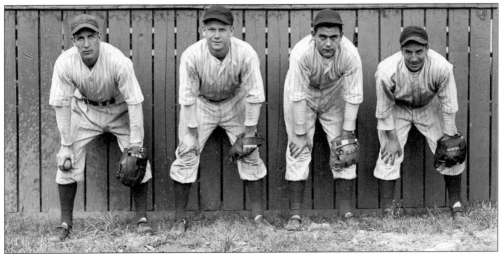

NORFOLK TARS STARTING INFIELD, 1938. Manager Ray White's starting infield for the 1938 season, pictured from left to right, are the following: first baseman Ken Manning; second baseman Gerry Priddy; third baseman Aaron Robinson; and shortstop Phil Rizzuto. Manning slugged 12 homers and knocked in 57 RBIs during the season, despite the fact he was laid up several times because of injuries. Aaron Robinson started in the Yankees organization as a third baseman but was converted to catcher before finally making it up to the Bronx Bombers in 1946. Unfortunately he immediately lost his starting position to another former Norfolk Tar, Yogi Berra, during the 1947 season. Gerry Priddy and Phil Rizzuto formed one of the most dynamic double play combinations in the league and would both find themselves in Yankee Stadium by 1941. Priddy batted an impressive .323 during the 1938 season for the Tars and would later serve 11 years as a defensive specialist for a number of major league teams. Following his retirement from baseball he played professional golf on the PGA tour. (NPL.)

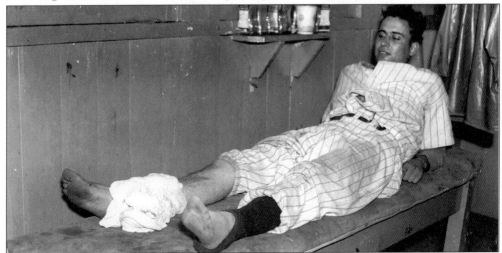

NORFOLK ACE ON ICE, 1938. Don Hendrickson, ace right-hander for the Tars, looks at the damage caused by a torrid second-inning line drive off the bat of Jake Early, the Charlotte Hornet catcher. The ball hit Hendrickson's shin and sent him to the trainer's table, located under the Bain Field bleachers, for some icing. X-rays taken at Sarah Leigh Memorial Hospital revealed no broken bones, only severe bruising. The Tar hurler was back in action a few days later without missing his next start in the Norfolk pitching rotation. (NPL.)

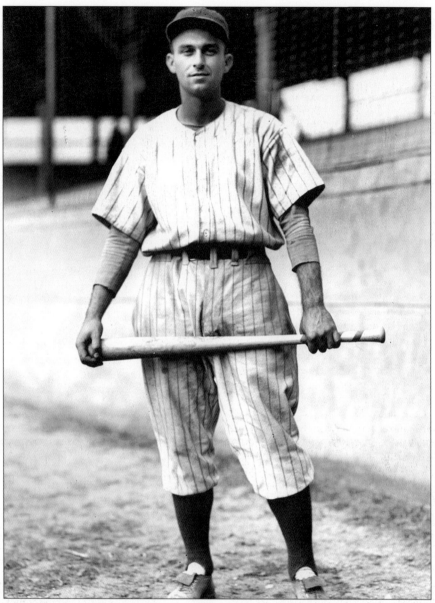

NORFOLK'S CLAUDE "KID" CORBITT, 1938–1939. Tars manager Ray White had quite a dilemma on his hands for the 1938 season. The Yankee organization was interested in a recent signee out of Duke University to fill their shortstop position, Claude Corbitt. Manager White played both Corbitt and another prospect, Phil Rizzuto, in the infield and finally came to the conclusion that Rizzuto was his man. The Norfolk skipper heard plenty of flack from the bleachers for his decision to bench Corbitt, since he was a popular fan-favorite at Bain Field. Striking an impressive pose for the photographer while gripping his weapon of choice, it would take the "Kid" another season before he could fully claim the shortstop position for the Tars. He proved himself to manager Ray White in 1939 and was able to contribute much-needed power at the plate with an impressive .338 average. Corbitt would finally enter the major leagues in 1945 as a Brooklyn Dodger and finish his career three seasons later with the Reds in Cincinnati. (NPL.)

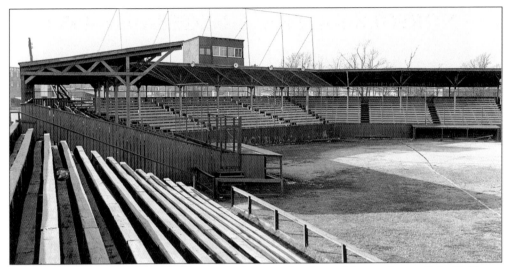

BAIN FIELD BLEACHERS, 1939. This stark photograph taken of the seating at Bain Field was shot during the winter of 1939, just before the city decided to tear down the legendary ballpark and construct High Rock Park. The field itself began as League Park and was referred to by that title up until 1927. When Norfolk entered the Eastern League in 1931, the park was renamed Bain Field. Improvements such as the removal of the high outfield fences, increased seating for "Negro patrons," and a partially covered bleacher section down the first base line were made. The park was located on 20th Street, close to the Church Street intersection, with the Sunlight Cleaners's smokestack towering over the right field wall. The new High Rock Park was built in the spring of 1940, just a short fly ball away, where Rugby and Church Streets met next to the railroad tracks. (NPL.)

H.P. DAWSON, 1939. Born in Halifax, North Carolina, Col. Henry P. Dawson had a long history of involvement with local baseball. He served as president and part-owner of the Portsmouth Truckers of the Virginia League from 1919 to 1921 and the Newport News Shipbuilders in 1922. Dawson was hired by the New York Yankees organization in 1932, and was selected by Jack Ruppert to head up the new Norfolk franchise in 1934. Dawson would serve as the Tars's business manager until the team was sold to local investors after the 1953 season. He is responsible for signing many future major league players to professional contracts, including Pie Traynor in Portsmouth, Lew Burdette, Bobby Richardson, Allen Gettel, Aaron Robinson, Bob Porterfield, and Jim Coates. (NPL.)

NORFOLK BASEBALL NOTES 1934–1939

- During the first game of a doubleheader in Richmond on July 4th 1934, Tars manager Bill Skiff and pitcher Ray White were arrested in the fourth inning of the contest following a disputed in-side-the-park home run by the Colts's Danny Musser. Musser's hit was a clear triple to the right field corner of the park but then rolled under the clubhouse steps, allowing the runner to advance home. The Tars protested vehemently, fisticuffs broke out, and police were summoned to the field. Both Skiff and White were immediately taken under arrest to police headquarters. Norfolk business manager H.P. Dawson then tried to intervene and was hit in the forehead by a police officer's blackjack, resulting in a large gash that required six stitches. Dawson was treated at a local hospital and then escorted to the police station and placed under arrest along with White and Skiff. The Norfolk contingent was quickly released on bond and manager Skiff was back in the Richmond ballpark in time for the second game of the doubleheader.
- Norfolk's 21-year-old right-handed pitcher Cecil Spittler threw a near-perfect game against the Richmond Colts at Bain Field on July 24, 1934. Facing only one batter over the minimum, the Tars's ace struck out 15 Colts with the lone baserunner reaching first only as a result of a hit batter in the fifth inning. Flawless fielding and plenty of offense by the Tars supported the masterpiece as Norfolk blanked the Colts 7–0. Interestingly, manager Bill Skiff penciled Spittler in as his starting pitcher only moments before the game began when Tom "Shakey" Kain complained of a sore arm.
- On May 10, 1935 in a game against Wilmington, the Tars managed to squander a lead in the eighth inning as the Pirates sent three runners over the plate. Manager Bill Skiff rallied his Tars in the top of the ninth and with one out the team responded with a 15-run barrage resulting in an exciting 20–8, come-from-behind victory. In the final inning the Tars hit three home runs and two singles as Wilmington committed two costly errors and walked a total of five batters.
- On June 11, 1936, a young Johnny Vander Meer of the Durham Bulls struck out 19 Norfolk Tars and was nicked for only one hit in a close 1–0 victory. The rival hurler for the Tars, Joe Bob Mitchell, turned in an impressive performance himself by striking out 10 Bulls and allowing only two hits. The lone hit given up by Vander Meer was to Mitchell, the Tars pitcher.
- Allen "Two Gun" Gettel signed with the Norfolk Tars as a 19-year-old and pitched one game during the 1936 season. His lone appearance came in a tough nine-inning complete game defeat where he gave up 14 hits and 10 runs. Gettel worked his way through the New York Yankees minor league system and returned to Norfolk seven years later, pitching for the Tars during the 1943 and 1944 seasons before heading to the majors.
- The final series of the 1937 Shaughnessy Playoffs between Norfolk and Portsmouth was a hard-fought duel with tempers flaring and fights erupting during the three-game set. By sweeping the Cubs, the Tars were awarded $1,500 to be split among their players while the Portsmouth team earned a total of $750 as runner-up.
- The premier double-play combination during the 1938 Piedmont League season consisted of Norfolk shortstop Phil Rizzuto and second baseman Gerry Priddy. This dynamic duo completed 157 twin-killings over the season and topped the league in this category by a wide margin.
- During their first six seasons in the Piedmont, the Tars proved to be one of the most dominating teams in the league. Over that short span Norfolk captured three league pennants (in 1934, 1936, and 1938) and three playoff titles (in 1934, 1936, and 1937).

SAM CHAPMAN AND BOB FELLER, NORFOLK TRAINING STATION, 1942. Cleveland Indians fireballer Bob Feller was one of the first major leaguers to temporarily forgo baseball and take up arms in World War II. On January 6, 1942, at age 22, Feller enlisted in the Navy and was assigned to Norfolk after boot camp. Despite his willingness to immediately enter combat, the Navy convinced the Cleveland ace to take the rank of Chief Specialist Athletic (CSA) and play ball for the Naval Training Station (NTS) team. His role was to entertain the troops along with approximately 20 other professional ballplayers that recently signed up for naval duty. Among them was Sam Chapman, the catcher for the Philadelphia Athletics. In this photograph, Chapman (left) and Feller (right) leave their quarters in their newly issued Navy garb. Feller, Chapman, and a host of other major leaguers would put on quite a show over the 1942 season and finish the year with an incredible 92–8 record. (CSTG.)

FOUR

Swabee Swingers
and Slingers

Navy Baseball during the War Years

The incessant rumbling of wartime thunder began reverberating across the nation in the 1940s. Norfolk, with its long maritime history and home to the world's largest naval facility, was quickly caught up in the frenzy and anticipation of how President Roosevelt would handle the impending crisis in Europe and the growing threat of the Japanese empire in the Pacific. On December 7, 1941, the attack on Pearl Harbor propelled America into World War II and the country rallied around the President as a declaration of war was delivered. Thousands of Americans enlisted and raised their hand to vow a newfound allegiance to the country while wearing a uniform of the Armed Forces. Along with the everyday "Joe," celebrities were called upon and enlisted to support the cause. Actors, writers, politicians, singers, and athletes found themselves in Jeeps and destroyers instead of limos and yachts. Camouflaged gabardine became the cloth of choice instead of brightly colored imported silks.

As the rolls of the celebrity inductees grew, it was evident that many of the nation's professional baseball players were more than willing to give up their playing careers to support the country on the warfront. One of the first to announce his enlistment was Cleveland Indian pitcher Bob Feller. "Rapid Robert" was the premier pitcher in all of baseball, yet he put his career on hiatus to join the Navy only days after Pearl Harbor. Other baseball professionals that followed soon after included Fred Hutchinson of the Detroit Tigers, Sam Chapman of the Philadelphia Athletics, and Vinnie Smith of the Pittsburgh Pirates. After boot camp, these former major leaguers were assigned to the Norfolk Training Station to begin their new wartime duties.

In the past, baseball teams at the Norfolk Naval facility were formed to give sailors a diversion from training. Little attention was given to these teams until the Navy brass decided to promote the newly enlisted major league players to Chief Specialist Athletic and add their talents to the station's baseball team. As can be imagined, the often-ignored Norfolk Training Station (NTS) team now created quite a stir on the base, as most of the players in uniform were fresh from the American, National, and minor leagues.

In March 1942, a formal team and schedule were announced with Chief Signalman Gary Bodie at the helm. While the new skipper was known as a fierce and competitive leader he was no baseball expert. Bob Feller later stated that Bodie did what most managers should do, "stay out the way and let us play."

And play they did. The schedule that was devised by Capt. Henry A. McClure, the commanding officer of the Norfolk Training Station, found the "Blue Jackets" taking on a number of military, college, and major and minor league teams. With Feller, Chapman, and the others on the roster the team quickly established itself as a powerhouse no matter who their opponents happened to be. As the

season came to an end in September, the NTS Blue Jackets had accumulated 92 victories against only 8 losses. Following the season, the legendary 1942 team found many of its players moving on to training and assignments throughout the country and overseas. Bob Feller was transferred to the battleship USS Alabama and was on board during commissioning trials off the coast of Hampton Roads. Several of his teammates headed north to the Great Lakes Training Station.

With the loss of Feller and several other big league names, the 1943 Naval Training Station squad was never expected to remain a dominant force on the field. Captain McClure, known more for his love of the game than his knowledge of players, continued to pull from a ready reserve of anxious professionals assigned to Norfolk. Interestingly, a former Norfolk Tar from 1938 returned to the area and took his place as shortstop with the NTS nine. New York Yankees star Phil Rizzuto arrived and found himself sharing the locker room with Dom DiMaggio of the Boston Red Sox and an impressive assortment of other major and minor league stars.

The Navy could boast not only one great military team, but two. Just across the base, the Norfolk Naval Air Station (NAS) put a squad together that consisted of Brooklyn Dodgers great Pee Wee Reese, seasoned veteran Hugh Casey, and other professionals training as pilots or other supportive roles. During the 1943 baseball campaign, the NAS team gave the NTS Blue Jackets all they could handle with neither team establishing complete dominance over the other.

As both the NTS and the NAS continued to staff their teams with major and minor leaguers for the remaining two years of the war, the caliber of players diminished somewhat but the excitement and interest never wavered as sailors continued to make their way to the ballpark.

The Norfolk base had a classic ball field within its confines that was built just before the 1920s. The stadium was a handsome brick and steel facility that could hold several thousand sailors in its stands. The ballpark, known simply as the Norfolk Naval Station Stadium, was renamed McClure Field in honor of the commandant that contributed so much to create an exciting distraction for the lucky sailors stationed in Norfolk. The stadium, located on Farragut Avenue near many of the stately mansions constructed during the Jamestown Exposition in 1907, remains one of the oldest baseball facilities still in use.

As World War II came to a victorious end, the Navy teams reverted back to a more "amateur" status as the major leaguers returned to the professional ranks. The advent of the Korean War saw several major leaguers don the Navy flannels but the teams never attained the legendary status of the World War II years, when Norfolk truly had two of the most powerful teams in all of baseball.

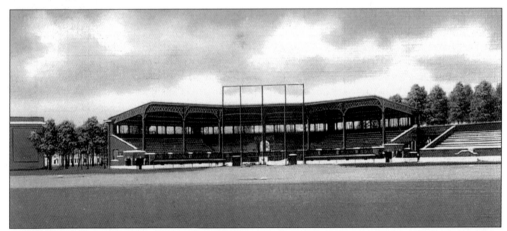

NORFOLK NAVAL TRAINING STATION STADIUM, 1940. Before it was renamed McClure Field in 1943, the ballpark shown in this vintage postcard was simply known as the Norfolk Naval Training Station Stadium. The handsome brick and steel ballpark is still utilized by military ball teams to this day. However, its most famous era came between 1942 and 1945 when it was the home field of the mighty NTS Bluejackets. (CSTG.)

LIEUTENANT COMMANDER GENE TUNNEY, 1941. Before the advent of Pearl Harbor and America's entrance into World War II, the Navy commissioned former heavyweight champion Gene Tunney as a Lieutenant Commander. Tunney first served his country as a U.S. Marine during World War I and throughout his boxing career was often referred to as the "Fighting Marine." By the age of 25 he won his first title fight and was crowned the American light heavyweight champion with a decision over "Battling" Levinsky in a 12-round bout. His most fierce rivalry was against the great Jack Dempsey. Tunney won back-to-back title matches in 1926 and 1927 against Dempsey, the latter being the infamous "Battle of Long Count." Over his illustrious boxing career, Tunney would win 77 bouts—43 by knockout—and retired as undefeated heavyweight champion of the world in 1928. Shown here in his dress whites, Commander Tunney was instructed by the Navy brass to organize a physical fitness program with his headquarters designated as Norfolk, Virginia. As the war broke out and professional ballplayers rushed to enlist, Tunney suddenly found himself recruiting and processing some of baseball's biggest names. Under his direction, the Norfolk Naval Training Station and the Norfolk Naval Air Station fielded squads that were packed with major league players in their prime. From 1942 until 1945, the two Navy teams from Norfolk were considered some of the most powerful in all of baseball. The athlete-recruits that were processed through the ex-boxing champion's office were nicknamed "Tunney's Fish." (NPL.)

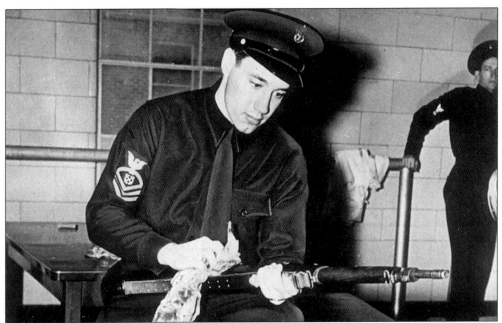

CHIEF SPECIALIST ATHLETIC BOB FELLER, NORFOLK NAVAL TRAINING STATION, 1942.
Following the completion of boot camp, Cleveland Indians ace Bob Feller was shipped to the
Norfolk Naval Training Station to begin work on acquiring the necessary skills to become a
gunner's mate. Shown here in these two rarely seen photographs, the 22-year-old Feller
completes a few of his daily routines, including squaring away his bunk and cleaning his rifle.
During his years in the Navy, Feller had the opportunity to see plenty of action in both the
Atlantic and Pacific theatres. Over a 36-month span, the young Chief was in charge of a 24-
man anti-aircraft crew on the USS *Alabama*. He was awarded five campaign ribbons and eight
battle stars during his time spent at sea in Tarawa, Iwo Jima, and the Marshall Islands.
(National Baseball Hall of Fame.)

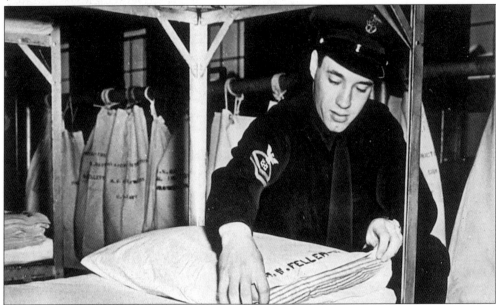

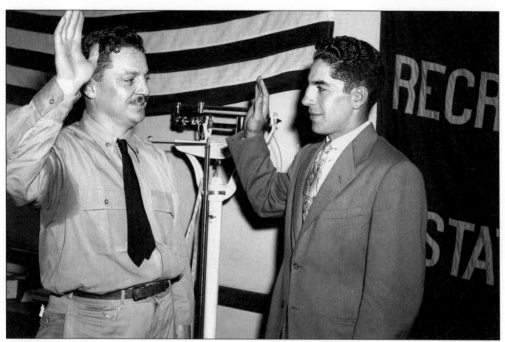

"Scooter" Gets Sworn In, 1942. New York Yankee and former Tars shortstop Phil Rizzuto made a special trip to Norfolk to join the United States Navy in support of the war effort. Administering the pledge to the young Rizzuto on September 7, 1942, is Lt. Comdr. John Quincy Adams, the officer in charge of the Norfolk Recruiting Office. Rizzuto, known as "Scooter" to Yankee fans everywhere, received the rank of Seaman First Class and was placed on inactive duty until told to officially report to the Norfolk Naval Training Station on October 10, 1942. Immediately following the swearing-in ceremony, the Yankee shortstop hopped a train to rejoin his teammates in Chicago for a series against the White Sox. (NPL.)

Rizzuto Ties the Knot in Norfolk, 1943. On the afternoon of Wednesday, June 23, 1943, Phil Rizzuto, former Tars shortstop, married his new bride. Once outfitted in Yankee pinstripes but now serving the nation in Navy bellbottoms, Rizzuto took Miss Cora Esselborn of Newark, New Jersey as his wife at St. Mary's Catholic Church near downtown Norfolk. The happy couple is shown here leaving the church, with Rizzuto in his Seaman's First Class uniform. After the obligatory photographs for the media, the entourage gathered themselves and headed to the Monticello Hotel for a reception. (NPL.)

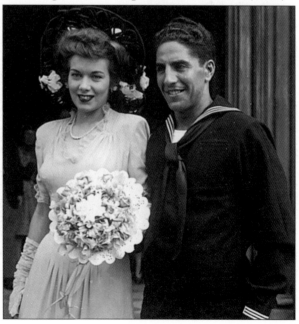

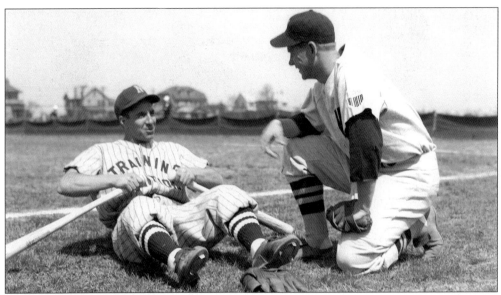

RIZZUTO SHOWS PRIDDY HOW THEY ROW A BOAT IN THE NAVY, 1943. When the Washington Senators visited Norfolk to take on the Naval Training Station nine in April 1943, two old acquaintances found themselves on the field together after several years of separation. Both former Norfolk Tars, shortstop Phil Rizzuto and second baseman Gerry Priddy hammed it up on the field as they prepared for a contest at the NTS field. Here Phil appears to be showing his old teammate the correct way to row a boat with a couple of baseball bats. Priddy and Rizzuto were the premier double play duo in the Piedmont League for the 1938 season and spent time in pinstripes with the New York Yankees before they split up and Priddy found himself covering second base with the Senators in Washington, D.C. (NPL.)

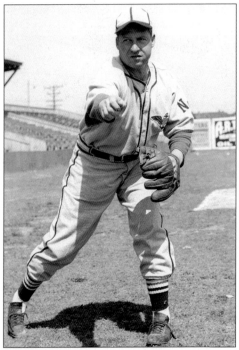

HUGH CASEY, NAS PITCHER, 1943. The big arm for the Norfolk Air Station Flyers was Brooklyn Dodgers veteran pitcher Hugh Casey. Casey turned in winning records for the Dodgers from 1939 until his enlistment in the Navy midway through the 1942 season. Shown here in a classic pitching pose, Casey would pitch a convincing no-hitter against the rival NTS nine on April 26, 1943. The War Bond Benefit game drew over 7,000 admiring fans to see two of the best teams in all of baseball compete at Norfolk's High Rock Park. After fulfilling his service commitment, Hugh Casey returned to the Dodgers and continued his winning ways, accumulating 75 victories against only 42 losses during his 9 years in the majors. He was known for his heavy drinking and boisterous behavior and ended his own life by suicide in 1951, only two years after hanging up his glove. (NPL.)

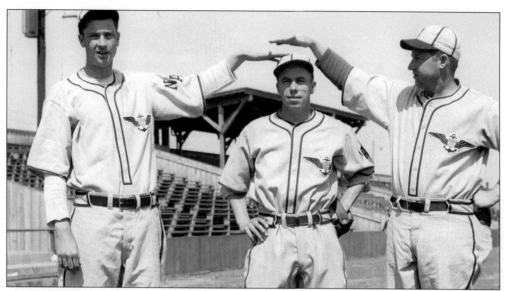

PEE WEE MEASURES UP TO EXPECTATIONS, 1943. Despite his short stature, veteran major leaguer Harold "Pee Wee" Reese never had a problem measuring up against the big men on the Norfolk Air Station's squad. Shown here clowning around before a War Bond game at High Rock Park are pitcher Charley Whelchel (left) and hurler Hugh Casey (right), with Pee Wee Reese getting the short end of it in the middle. While most believe that Reese was given his name because of his height, it was actually a title earned because of his talent for shooting marbles in his neighborhood as a young boy. (NPL.)

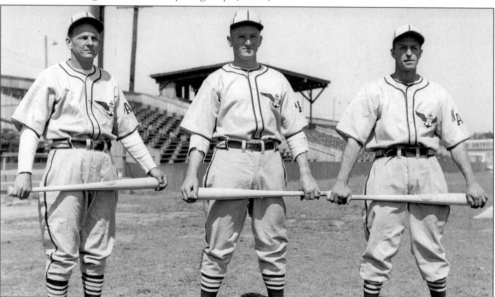

BIG STICKS FOR THE NORFOLK NAVAL AIR STATION FLYERS, 1943. Posing with their bats in front of the third-base bleachers at Norfolk's High Rock Park is the starting outfield for the 1943 Norfolk Naval Station Flyers. Hub Walker (left) began his major league career in 1931 with the Detroit Tigers, while Chet Hajduk (center) appeared in only one game with the Chicago White Sox in 1941 before his enlistment in the Navy. Bubber Hart, a hard-hitting addition to the Navy team, never made it to the major leagues. (NPL.)

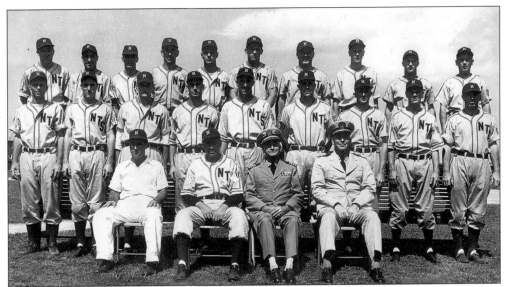

NORFOLK NAVAL TRAINING STATION TEAM, 1944. Posed on the infield grass of McClure Field is the 1944 Norfolk Naval Training Station team. As the 1944 season concluded, the team boasted another dominating campaign as they won 83, lost 22, and tied 2. While many of the big-name major leaguers had already passed through the team in 1942 and 1943, the 1944 squad still had many stars wearing Navy uniforms. Pictured in the front row is Mush Esler (trainer), Gary Bodie (manager), Captain McClure, and Commander McDonald. Former major leaguers on the roster included Jack Conway, Tommy Byrne, John Rigney, Eddie Robinson, Jeff Cross, Jack Robinson, Mel Preibisch, Frank Marino, Benny Huffman, Russ Meers, Red McQuillen, and Henry Schenz. (CSTG.)

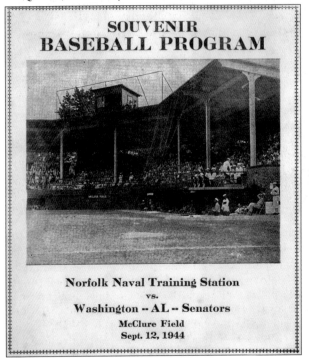

SOUVENIR BASEBALL PROGRAM

Norfolk Naval Training Station
vs.
Washington -- AL -- Senators
McClure Field
Sept. 12, 1944

FINAL GAME PROGRAM, 1944. The nearly invincible Norfolk Naval Training Station team wrapped up their 1944 campaign with a convincing 6–3 victory over the Washington Senators in front of over 8,000 sailors at McClure Field. The September 12th win was credited to former Chicago White Sox hurler Johnny Rigney, as he held the American Leaguers to only seven hits during the contest. Special guests for the sailors' final match of the year included Frank D. Lawrence, owner of the Portsmouth Cubs, and his celebrated manager, Jimmie Foxx. (Collection of Ron Pomfrey.)

NTS vs. Senators Program, 1945.
The Washington Senators made their
yearly journey to Norfolk and played a
three-game series against the Naval
Training Station squad at McClure
Field during the early days of April
1945. Each of the contests drew
capacity crowds of over 8,000
enthusiastic sailors to see their Navy
team evenly divide the series with one
win, one loss, and one tie. The
Bluejackets were led by former major
league veterans Clyde McCullough and
Ace Parker, both of whom hit towering
home runs in the final game of the
series, which ended in a 9 to 9 deadlock
after 10 innings. During the April 1st
contest, the Senators inserted Lt. Bert
Shepard, the one-legged veteran pilot,
as a relief hurler. He kept the NTS
squad hitless during an inning of work.
As was usually the case, Washington
Senator coach and comedian Nic
Altrock entertained the sailors before
each game. (CSTG.)

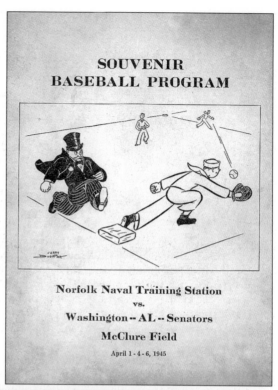

SOUVENIR
BASEBALL PROGRAM

Norfolk Naval Training Station
vs.
Washington -- AL -- Senators
McClure Field

April 1 - 4 - 6, 1945

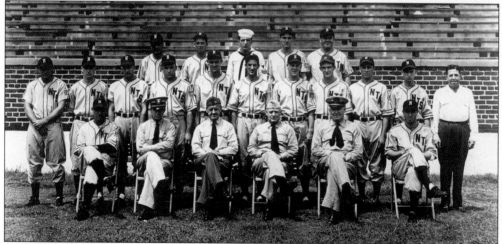

Norfolk Naval Training Station Team, 1945. With the brickwork that surrounds
McClure Field behind them, the last of the great World War II Norfolk Naval Training Station
teams poses for this final picture of the 1945 season. The squad continued to stock its roster
with former major leaguers and posted an impressive 50–23 record through August 30th. Posed
on the front row from left to right are Coach Ace Parker, Lieutenant Commander King,
Captain McGurl, Commodore Clarke, and Lieutenant Commander MacDonald. In the second
row from left to right are Clyde McCullough, Jimmy Coyle, Jeff Cross, Max Surkont, Roy
Allen, Joe Rustick, Jack Robinson, Joe Murray, Dom Caniglia, John Neeper, and trainer Fitz
Lutz. In the top row (from left to right) are Ernest DeVaurs, George Meyer, scorer Harry
Postove, Bill Deininger, and Sig Broskie. (National Baseball Hall of Fame.)

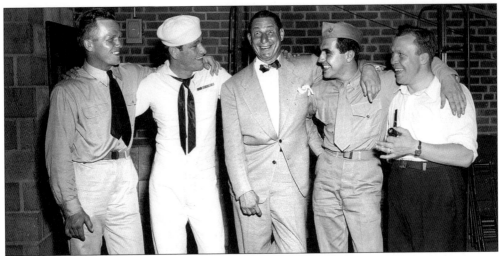

WAR BOND RALLY DRAWS CELEBRITIES AND HEROES TO THE NORFOLK NAVAL STATION, 1945. As part of a continuing effort to help fund the war effort, the Navy was never shy to ask the nation's celebrities to appear at various war bond events. Many headline performers from radio, cinema, and athletics signed on in droves. On June 28, 1945, the Norfolk Naval Station organized a carnival that included boxing matches, a live nationwide radio broadcast, and vaudeville acts for a large audience that contributed $1,000,000 in war bonds. The photograph shows (from left to right) Marine Corps private Rene Gagnon, Pharmacist's Mate John Bradley, Al Schacht ("The Clown Prince Of Baseball"), former World Lightweight boxing champion Lou Ambers, and World Middleweight boxing champion Tony Zale. Gagnon and Bradley were showcased during the event as two of the three remaining heroes that raised the American flag on Mount Suribachi at Iwo Jima. (NPL.)

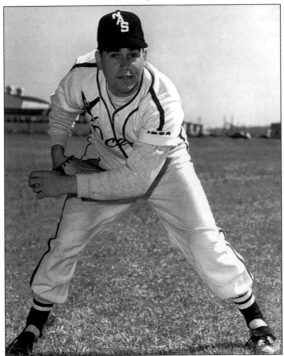

"LEFTY" KELECAVA, 1953. The Korean War inflated the ranks of the military teams in and around the Norfolk area but never matched the quality and prestige of the infamous World War II squads. Pictured here in a classic pose, "Lefty" Kelecava wore the uniform of the Norfolk Air Station Flyers in 1953. He would later don the pinstripes of the Norfolk Tars for eight games before being shipped off to the Hagerstown Packets for the remainder of the 1954 season. (CSTG.)

NAVY BASEBALL NOTES

- Hugh Casey, the dominating hurler on the Norfolk Naval Air Station team during the 1943 season, was known to celebrate his victories on the mound with more than a few shots from the bottle. As a Brooklyn Dodger in the early 1940s, he spent spring training in Cuba and became acquainted with author Ernest Hemingway, another heavy drinker. During a visit to Hemingway's Cuban home while both were working on a shared bottle, the author challenged Casey to a boxing match. With Hemingway reportedly getting in a few shots with little effect, Casey had had enough of the "light" sparing and knocked "Papa" out cold. The two continued a mutual relationship with hunting, drinking, and boxing. Interestingly, both ended their lives by suicide.

- Capt. Henry McClure, the commanding officer of the Norfolk Naval Training Station, took his team and winning quite seriously. During a War Bond Benefit game in New York he reportedly chased Bing Crosby out of the dugout while the crooner was sitting and talking with some of the Navy players before the game began.

- The Navy had an overabundance of talent in 1943, which created a problem that many owners and managers would love to have: too many great shortstops to pencil into the roster. With Phil Rizzuto already anchoring down the position with the Naval Training Station, Captain McClure received another new recruit that was interested in playing: the Brooklyn Dodgers's great Pee Wee Reese. With no opportunity to play with the NTS nine, McClure sent the veteran shortstop to the other side of the base to play for the Norfolk Air Station team.

- During April 1942, the Norfolk Naval Training Station team had amassed a record of 19 wins against only 2 defeats. The highlight of the early portion of the campaign came during a game against the Wilson (North Carolina) Tobs of the Bi-State League when Navy ace Bob Feller fanned 22 batters in a lopsided victory.

- Chief Gary Bodie, a somewhat reluctant manager overseeing the multitude of major league talent on the NAS squad, was often ignored by the players when he gave directives or laid down signs during the contests. He was once quoted as saying that if the team kept ignoring his signals he would send them all to signalman school located near the ball field on the Naval Base.

- While Capt. Henry McClure was an avid baseball fan he did not profess to know much about the sport at the major league level. During a 1944 interview with Washington sports writer Shirley Povich, he asked if a pitcher named Vander Meer would be worthwhile to have on the Naval Training Station team. At this point in his career, Johnny Vander Meer had just finished leading the National League in strikeouts for three consecutive years and had pitched back-to-back no-hitters in 1938. McClure knew nothing of his exploits.

- By 1945, long-time Naval Training Station manager Gary Bodie was replaced by Clarence "Ace" Parker, a native of Portsmouth and a star quarterback in the National Football League. "Ace" knew how to swing a bat and field a ball from time spent with Connie Mack's Philadelphia Athletics in 1937 and 1938.

- Throughout the war years a number of high profile War Bond Benefit games were played throughout the country featuring the Norfolk Naval Training Station team. Their popularity in both the military and civilian arenas raised over four million dollars for the purchase of war bonds and to assist with the Navy-Marine Corps Relief Society.

TARS, CUBS, AND COPS: SEPTEMBER 14, 1937. The ongoing rivalry between the Norfolk Tars and the Portsmouth Cubs erupted once again during the opening game of the 1937 postseason championship series at Bain Field. With both Portsmouth and Norfolk eliminating their opponents during the first round of the Shaughnessy Playoffs, the two teams faced off on September 14th with the fireworks beginning in the first inning of the contest. Cubs slugger Bill Nicholson gave the visitors an early one-run lead that quickly eroded as the Tars answered with six runs in the bottom of the inning, capped by a grand slam from third baseman Pete Suder. Portsmouth continued to chip away at the lead but was stymied by the excellent relief work of Tars reliever Lefty Crutchfield. In the seventh inning, Cub second baseman Eddie "The Brat" Stanky was caught looking at a called third strike. Stanky and Portsmouth manager Elmer Yoter soon found themselves face-to-face with umpire Barbare arguing the call. After some well-chosen words were offered, Yoter was ejected and the entire Cubs squad surrounded the umpire in protest. Stanky found himself in the middle of things and was also thrown out of the game. As confrontations escalated, the ballpark photographer snapped this shot from the press box, revealing that it took five Norfolk police officers to restore order. As the hotly contested game came to an end, the Tars found themselves one game up on the Cubs in the series with an impressive 11–5 victory. Norfolk would go on to sweep Portsmouth for the trophy in three games. (CSTG.)

FIVE

Cross-River Rivals

Jubilation, disappointment, elation, and frustration are the myriad of emotions a baseball fan experiences during a closely fought match on the diamond. Feelings become magnified and senses electrified when the visiting opponent has a reputation of making each game a nail-biting experience. The close proximity of several cities in the Hampton Roads area provided the Norfolk baseball club with more than a few classic rivalries over the years.

As professional baseball gained popularity in Southeastern Virginia toward the end of the 1800s, Norfolk, Portsmouth, Newport News, and Hampton contracted ballplayers and soon found themselves matched against one another in league schedules. As early as 1894 Hampton, Newport News, and Norfolk arranged contests between one another as members of the Virginia League, with Portsmouth and Norfolk beginning their classic rivalry the following year. Each city fielded a professional team at one time or another, staging lively and often heated contests with their neighbors.

Despite the number of cross-river rivalries in the area, none flared with the type of intensity as when Portsmouth and Norfolk met on the local diamonds. Just a short ferry crossing over the historic Elizabeth River, fans could easily view "road" games of their favorite team in its rival's ballpark. On more than one occasion, Portsmouth and Norfolk staged "home and away" doubleheaders, with the first game of the day played in Portsmouth and a later afternoon contest scheduled in Norfolk, or vice versa. Fans, players, and officials would board the ferry together and meet at the ballpark for a full day of baseball.

In the city of Portsmouth, no one epitomized baseball more than Frank D. Lawrence. As a fledgling banker in 1914 he purchased the struggling Portsmouth Truckers of the Virginia League and began a long and respected career as a benevolent, popular, and hands-on owner. Lawrence was the guiding force in the construction of Portsmouth Stadium near the Scott's Creek section of the city and continuously funded a team that brought fans to the ballpark until the demise of the Piedmont League in 1955. Known to possess an eye for talent, he was credited for signing Pie Traynor and Hack Wilson to playing contracts and convinced veteran, big-name ballplayers such as Tony Lazzeri, Milt Stock, and Jimmie Foxx to coach his team. He was well loved and admired in Portsmouth and often received the loudest round of applause when he made special appearances at Norfolk's ballparks. In 1964, Portsmouth Stadium was renamed Frank D. Lawrence Stadium in his honor.

Fights broke out on the field on a rather consistent basis and more than once, police were called in and proved to be the only means to restore order on the diamond. Hard throws, high slides, hit batters, and verbal insults contributed to individual player rivalries between the two squads. For the Portsmouth Cubs, no other player elicited more hostility from his opponents than Eddie "The Brat" Stanky. The five-foot-eight-inch, 170-pound second baseman always seemed to find himself in the middle of things and was often the first off the bench when players erupted into fistfights. His feud with Norfolk Tar Gerry Priddy during the 1938 season is legendary, and fans flocked to the ballparks knowing that sparks were going to fly sometime during the contest.

The Newport News Dodgers (with players such as Duke Snider, Chuck Connors, and Gil Hodges) and the Portsmouth Cubs (with Ace Parker, Reggie Otero, and Kenny Guettler) both proved to be formidable opponents for the Tars over the years. The classic rivalries that ensued for close to a century surely left local baseball fans waiting in anticipation for the next scheduled re-match.

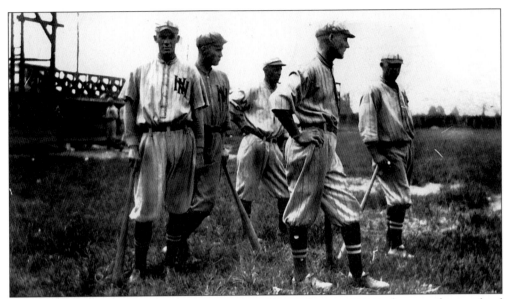

THE SHIPBUILDERS OF NEWPORT NEWS, 1919. Shown here surveying the ragged grounds of East End Park in the spring of 1919 are four ball players of the Newport News Shipbuilders, member of the Virginia League. With the league re-organizing in 1919 following instability throughout the war years, the team could only fashion a 42–69 record and found themselves in last place. The franchise continued with the league until it moved to Petersburg to become the Trunkmakers for the 1923 season. Johnny Gooch, the team's catcher, is the second player from the left in the photograph. A natural switch-hitter, he batted an impressive .342 in 79 appearances at the plate. Following his days in Newport News, Gooch would play 11 seasons in the major leagues, mostly with the Pittsburgh Pirates. (CSTG.)

THE FATHER OF PORTSMOUTH BASEBALL. A career banker whose first love was baseball, Frank D. Lawrence was the driving force behind the game for over 40 years in the city of Portsmouth. Lawrence served as president of the Portsmouth Truckers of the Virginia League beginning in 1914 and brought baseball back to the city in 1935 as a part of the Piedmont League. Known for his strong beliefs in minor league baseball, he was an active and vocal proponent in getting legislature passed that would permit the sport to be played on Sundays. He was honored by *The Sporting News* in 1943 as "Minor League Executive of the Year." (NPL.)

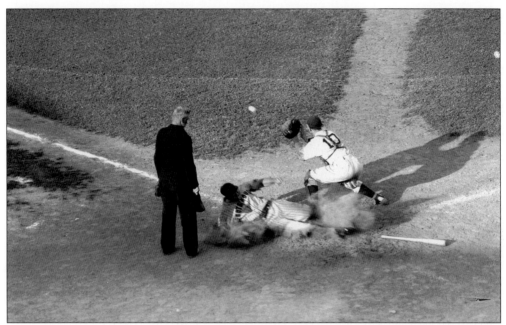

BILL NICHOLSON SAFE AT HOME FOR THE CUBS, 1937. The first playoff game of the postseason found the Portsmouth Cubs at Bain Field taking on their archrivals, the Norfolk Tars. Pictured here is Bill Nicholson of Portsmouth sliding across the plate in the third inning as catcher Charlie Fallon awaits the throw. Portsmouth's hometown hero, "Ace" Parker, drove Nicholson home with a single. Norfolk emerged with an 11–5 victory over the Cubs. (NPL.)

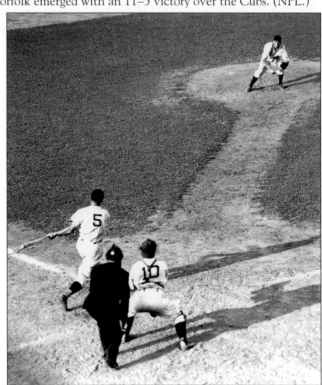

CUB CLAWS TAR FOR HIT, 1938. Portsmouth Cubs left fielder Ed Yount ruined a no-hit game by Tars pitcher Milo Candini in the sixth inning with a solid single through the Norfolk infield. The ball can be seen streaking past the pitching mound as Tars catcher Charlie Fallon and umpire Joe Cibulka watch the action from behind the plate. Candini would allow only one other hit during the August 23rd contest, as the Tars upended Portsmouth 9–1. (NPL.)

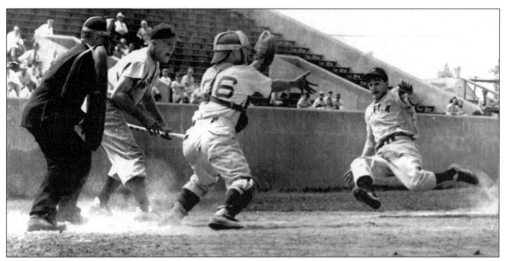

A Tar Stealing Home, 1947. Portsmouth Cubs catcher Harry Land readies himself for a throw from his surprised battery mate in an effort to cut down Norfolk Tars left fielder John Boryk at the plate. The photograph catches the action and freezes Boryk in mid-slide as an unidentified Tars player shouts his encouragement from the batter's box. Both Norfolk and Portsmouth would finish the season with almost identical records, more than 20 games behind the Piedmont League champion Roanoke Red Sox. The sparse number of fans in the bleachers at Portsmouth Stadium reflects that the teams were out of the running for the flag. (From the archives of Harry Land.)

Abe Goldblatt and Tom Fergusson. Toasting with some mysterious elixir in the photography department of the *Norfolk Virginian-Pilot*, veteran sports reporters Abe Goldblatt and Tom Fergusson celebrate another banner year of baseball in the Tidewater area. For countless seasons during the summer, Abe covered the Portsmouth Cubs, while Tom reported on the Norfolk Tars. Between these two fine and respected journalists, the fans could count on picking up the daily newspaper and finding interesting features regarding the local teams. (VP.)

PORTSMOUTH CUBS RUN UMP UP A TREE, 1949. On the afternoon of April 23, 1949, the Portsmouth Cubs and the Tars squared off for the Piedmont League opener in Norfolk in front of 4,500 enthusiastic fans. Mauri Partain of the Cubs lofted a high fly ball that appeared to clear the left field fence; however, umpire Malcovic ruled it foul and was immediately surrounded by catcher Ted Pawelek, third base coach Harry Land, and player-manager Skeeter Scalzi (#3). In the background are the segregated stands reserved for African-American fans that came to cheer on the Tars. (CSTG.)

SPECIAL DUDS FOR DODGERS, 1950. With Bermuda shorts first being worn on the west coast by the Hollywood Stars team of the Pacific Coast League in the late 1940s, it was only a matter of time before the fad drifted eastward. During the 1950 season, the Newport News Dodgers adopted "shorts and socks" as their summer uniform and showcased their new duds at Myers Field in a July game against the Norfolk Tars. Shown here are two Dodgers modeling their new attire for a young lady that seems to be giving her approval. Bud Metheny, the manager of the Baby Bums, gave the new style a positive review despite the scant coverage it provided a player sliding into second base. (NPL.)

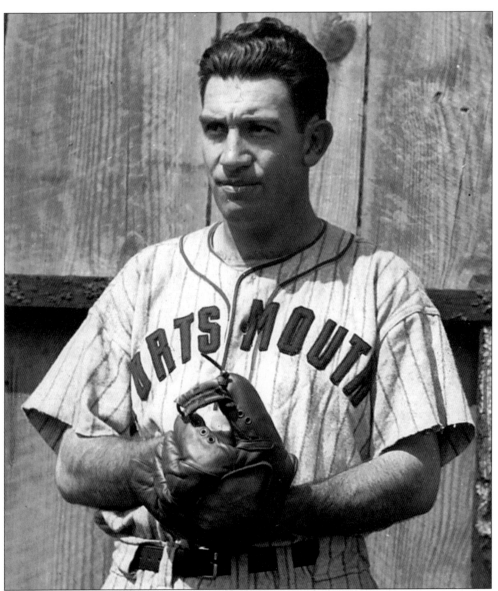

A THREAT IN ANY SPORT, PORTSMOUTH'S ACE PARKER. Pictured here in a Portsmouth Cubs uniform is multi-sport legend Clarence "Ace" Parker. Hailing from the Churchland section of Norfolk County, Ace attended Portsmouth's Woodrow Wilson High School, excelling in football, baseball, track, and golf. As a quarterback at Duke University he earned All-American honors and in 1936 began his professional career with the Brooklyn Dodgers of the National Football League. Not surprisingly, Ace spent his summers playing professional baseball from 1937 until 1952. He first set foot in a major league batter's box on April 30, 1937, with the Philadelphia Athletics and hit a home run in his first at-bat. His most productive years on the diamond came with his hometown Portsmouth Cubs, when he led the Piedmont League in hitting with a .331 average during the 1946 season. Ace is best known for his exploits on the gridiron where he toiled for seven seasons, earning several All-Pro honors and being named the NFL's Most Valuable Player in 1940. In 1972, Parker was honored with enshrinement as a member of the National Football Hall of Fame. (CSTG.)

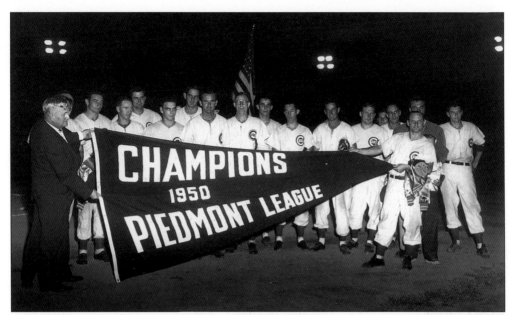

PORTSMOUTH CUBS, CHAMPIONS OF THE PIEDMONT, 1950. Owner Frank D. Lawrence and manager Skeeter Scalzi proudly unfurl the pennant that would fly over Portsmouth Stadium proclaiming the Cubs as Piedmont League Champions for the 1950 season. The honor was a team effort led by first baseman Reggie Otero's .353 average and Earl Mossor's 20–10 record from the mound. (CSTG.)

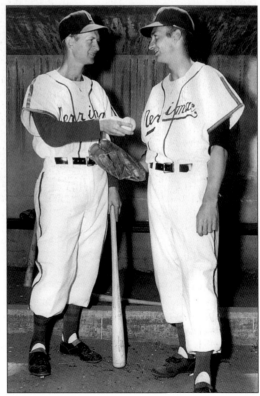

A PAIR OF MACS, 1953. For the final three seasons in the Piedmont League the Portsmouth Cubs changed their moniker to the Merrimacs, affectionately known as the "Macs" to players and fans. Shown here in the dugout at Portsmouth Stadium is Merrimac manager Bob Ankrum (left) handing the ball over to his workhorse hurler Bill Williams. Williams pitched for Portsmouth in 1952 (10–10) and 1953 (14–15). Ankrum managed the franchise for a single season in 1953 and guided the Macs to a 72–63 record in the Piedmont. Despite their winning record the Merrimacs would finish the season in fourth place, more than 10 games behind the pennant-winning Norfolk Tars. (VP.)

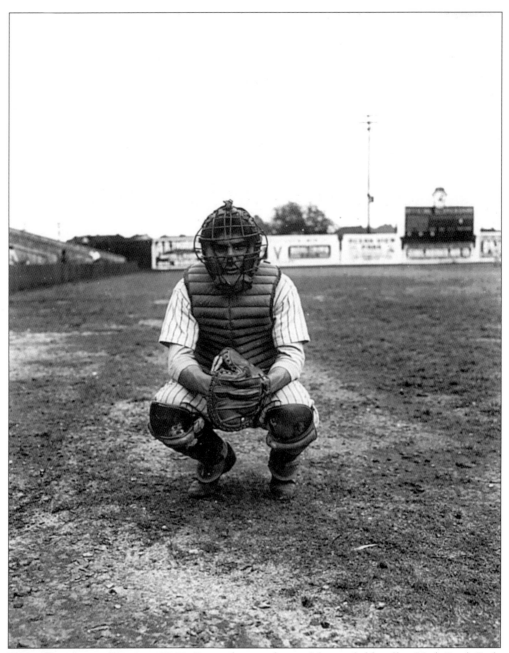

BERRA READY FOR BATTLE, 1943. Posing here in front of the outfield wall at High Rock Park is the 17-year-old rookie catcher for the 1943 Norfolk Tars, Lawrence Peter "Yogi" Berra. Yogi would eventually become a New York Yankee in the spring of 1946 and spend all but four games of his playing career with the Bronx Bombers until hanging up his spikes as a New York Met in 1965. He proved to be one of the most dominating hitters in World Series history and still ranks as a leader in game appearances, at bats, hits, and doubles for the Fall classic. A childhood friend gave Berra's famous nickname to him after watching a travelogue on India. Thinking that a Hindu yogi in the film bore a remarkable likeness to his friend, he began using the tag "Yogi" and the name stuck. (CSTG.)

70

SIX

The Norfolk Tars
Lean Years and Legends

A number of events shaped the 1940s for Norfolk baseball fans. With impending involvement of the United States in war-stricken Europe, Americans were preoccupied with the realization that the aggression of the Axis powers was a threat that must be faced in the very near future. Citizens throughout Norfolk were keenly aware of the military buildup for the war. Young sailors clogged Granby Street looking for nightly entertainment and exotic diversions to lighten their apprehension while training at the Norfolk Naval Base. Many others found their way to 20th Street and passed through the turnstiles of old Bain Field to catch the Norfolk Tars engage in an exciting game of baseball.

This turbulent decade would find the Tars still under the ownership of the New York Yankee organization and stocked with future major leaguers on their way up from the minor leagues. With the surprise attack on Pearl Harbor, the country and its national pastime were immediately thrown into turmoil. Young men, both in and out of baseball, found themselves lining up for enlistment in the armed forces. The Yankees struggled to keep their major league team filled and competitive. As would be expected, the minor leagues were often left with a lesser caliber of player than fans in Norfolk had been accustomed.

If the trepidation of eminent war was not enough to ponder, it became public knowledge that as early as January 1939, the Yankees were less than pleased with the condition of Norfolk's Bain Field. The legendary ballpark had served the city through the chaotic years in the Virginia and Eastern Leagues, as well as in recent seasons in the Piedmont. However, the state of the ballpark was deteriorating at a rapid pace and New York demanded that the city spend $100,000 refurbishing the seating and playing field to their standards. The Norfolk City Council balked at the demand and the Yankees took it one step further: they informed the city that there was strong consideration to play home games for the 1940 season in Portsmouth's newly constructed and state-of-the art stadium. As word of this challenge grew, the city suddenly found funds to finance the construction of a new stadium. With the Yankees agreeing to a 10-year lease at $5,000 a year and a local group of investors acquiring the deed for the property site, Norfolk would have its new playing venue and continue to secure a working agreement with the powerful New York franchise. The site of the new ballpark would be laid out on the corner of Rugby and Church Streets, not far from where Bain Field stood. The moniker of the new field came from a novel idea that decades later would become commonplace with national sporting arenas. The High Rock Bottling Company agreed to pay $1,000 a year for the naming rights to the new field, christened High Rock Park. With the first spade breaking ground in April, the builder had the field and stands ready in three short months. The first game in the new facility was scheduled for July 15, 1940.

Interestingly, the end of Bain Field would come with some unexpected fanfare. The Tars hosted Asheville on July 1, 1940 and closed out play at the old ballpark with a victory over the Tourists. During the game a section of the bleachers set aside for African-American fans caught fire and raged for almost 30 minutes before it was brought under control.

The 1940s would prove the Tars a mediocre team at best in the Piedmont League. Despite capturing only one league pennant (1945) and one Shaughnessy playoff championship (1943), there were a

number of future legends that plied their trade at High Rock Park. Chuck Connors, Vic Raschi, Yogi Berra, Bob Porterfield, Tom Gorman, Clint Courtney, Gus Triandos, and Whitey Ford all spent time with the Tars in that decade.

Tars manager Ray White continued as the skipper for the 1940 season with less than impressive results and Norfolk found itself mired deep in the second division of the league. Only George "Snuffy" Stirnweiss showed any power at the plate as he contributed a respectable .307 average and clubbed 12 home runs. He was the only Tar selected to the Piedmont League All-Star team for the season.

Veteran minor leaguer Eddie Sawyer was named the new manager for the Tars the following season and guided Norfolk to a winning record of 71–68, still well behind the pennant winning Durham Bulls. Sawyer had been a regular with the Tars in 1934 and would go on to serve as a major league manager in the future. As the war proceeded to drain the talent out of professional baseball, the Tars continued their downward spiral in 1942, ending the campaign in seventh place with an atrocious 57–79 record. Newcomer Chuck Connors, who would later garner fame as a cowboy television actor in the series "The Rifleman," held down the first base position for the Tars and showed some power with 5 homers during this dead ball era. Vic Raschi toiled for the Tars on the slab but was essentially ineffective, contributing more losses than wins for the team. The Norfolk nine often found themselves fodder for the visiting local Navy teams and were consistently drubbed by the Training Station Blue Jackets and the Air Station Flyers.

In 1943, 17-year-old Peter "Yogi" Berra donned pinstripes for the Norfolk Tars. A short, unimpressive looking catcher, Berra struggled throughout the season with his defensive skills behind the plate. While his catching skills were obviously raw at this stage in his career, Yogi had no difficulty swinging the bat. He swatted seven home runs and knocked in 56 RBIs during his one season with Norfolk before he would find his way to Yankee Stadium and later the National Baseball Hall of Fame.

The mid-point of the 1940s found former major league pitcher and Tars hurler Garland Braxton serving as player/manager for the team. His two seasons (1944–1945) brought back the winning tradition of the powerhouse Norfolk teams of the past. In 1945 the Tars would celebrate the end of World War II and a long overdue pennant in the Piedmont League.

The second half of the decade found the Tars consistently in the Piedmont's second division with only the 1946 campaign resulting in a winning record (71–69). Despite their lackluster performance as a team, the Tars were fortunate to have a number of star players. During the 1946 campaign the team found future Yankees Tom Gorman and Bob Porterfield hurling for the Tars. Both pitchers were retained for the 1947 season, with Gorman winning 8 games and Porterfield dominating the league in strikeouts (208) as he garnered 17 victories. The following season found the Tars with another young and promising pitcher, Edward "Whitey" Ford. The future Yankee legend dominated the league in strikeouts (171) and notched an impressive 16–8 record. Clint "Scrap Iron" Courtney served as Ford's battery-mate for the season. Certainly 1949 was the "Year of the Catchers," with both Courtney and big Gus Triandos working behind the plate for the Tars.

From the anxiety of the impending war followed by years of conflict overseas, to the construction of a new playing venue and finally the exuberance of an Allied victory, Norfolk fans experienced a wild ride for the course of the decade. As the 1949 season ended, few could foresee that the Tars were on the cusp of a reign of dominance never before seen in the history of the Piedmont League. Norfolk players, as well as their fans, were more than thrilled to close out the 1940s and let the 1950s begin.

HIGH ROCK PARK CONSTRUCTION, 1940. During the spring of 1940, with workers toiling seven days a week, the High Rock Park project was completed in little over three months. Shown here is George W. Bouch, assistant city engineer, surveying the layout of the new field. At the time of the photograph, workers were still painting the advertisements on the outfield walls and getting grass to grow in the outfield. Dimensions of the park were 411 feet to left, 400 feet to center, and a short 317 feet to the right field corner wall. The stadium was designed to seat 6,500 fans in the covered grandstands and outfield bleachers. The advertisement shown to the right was featured in a Norfolk Tars program during the 1943 season and promoted High Rock bottled soda, the corporate sponsor of the ballpark. (NPL.)

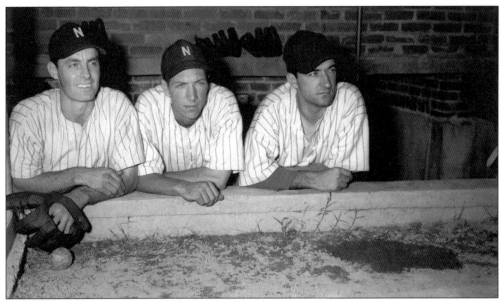

A Trio of New Tars Arrive at High Rock Park, 1941. Norfolk manager Eddie Sawyer was counting on the Yankee minor league brass to send him some help to fill weak spots on his 1941 roster. By the dog days of summer three new Tars arrived at High Rock Park for duty. Pictured here looking out from the dugout and surveying their new home is third baseman Mike Milosevich, outfielder Garrett McBryde, and pitcher Joe Garbarino. Despite manager Sawyer's hopes, the new arrivals were not effective and the Tars could only muster a fourth-place finish in the league. (NPL.)

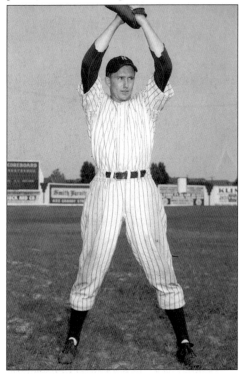

"Spec" Shea, the Naugatuck Nugget, 1941. Frank "Spec" Shea, nicknamed the "Naugatuck Nugget" in reference to his hometown in Connecticut, led the 1941 Tars with victories by posting a 16–10 season record. Shown warming up on the sidelines at High Rock Park before a scheduled start, his 3.17 ERA and 154 strikeouts did little to help Eddie Sawyer's Tars finish any better than with a mediocre 71–68 record. Shea would spend the war years in the military and finally make it up to the big leagues with the Yankees in 1947, compiling an impressive 14–5 rookie record. He pitched his last seasons with the Washington Senators and finished out his baseball career with a lifetime record of 56 wins against 46 defeats. (NPL.)

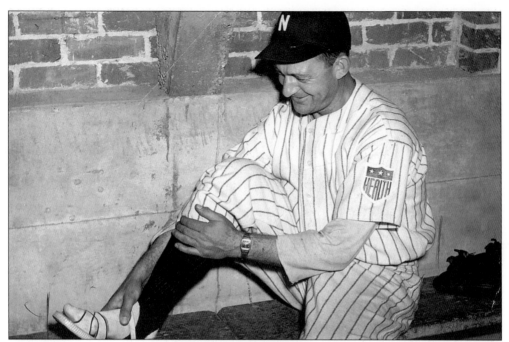

BUZZ BOYLE, NORFOLK TARS PLAYER-MANAGER 1942. Shown in the High Rock Park dugout sporting a special sandal designed to help with a recently twisted ankle, Boyle took the reins of the Norfolk Tars in 1942 from Eddie Sawyer. Boyle broke into the majors in 1929 with the Boston Braves and served two seasons before joining the Brooklyn Dodgers in 1931. During a long career in both the major and minor leagues, Boyle was known as an effective leadoff hitter and an outfielder with a great arm. He began his managerial career in 1941 as skipper of the Akron Yankees of the Class C Middle Atlantic League capturing the pennant. He would be unable to repeat his success during the 1942 season with the Tars, who were buried deep in the second division of the Piedmont League, posting a dismal 57–79 record. (VP.)

NORFOLK TARS HOME PROGRAM, 1942. This richly illustrated program was sold at High Rock Park for a Tars game during the 1942 season. The interior pages feature an opportunity for the fans to vote for their favorite Norfolk Tar with the popular player awarded a table model radio at the end of the season. Prices at the ballpark for concessions included "Red Hots" for 10 cents, 15 cents for a bottle of beer, a bag of peanuts for 5 cents, and a good cigar for only a nickel. Seat cushions could be rented for 10 cents, and were probably a good investment especially if a fan held a ticket for a place on the rough, wooden bleachers lining High Rock Park. (CSTG.)

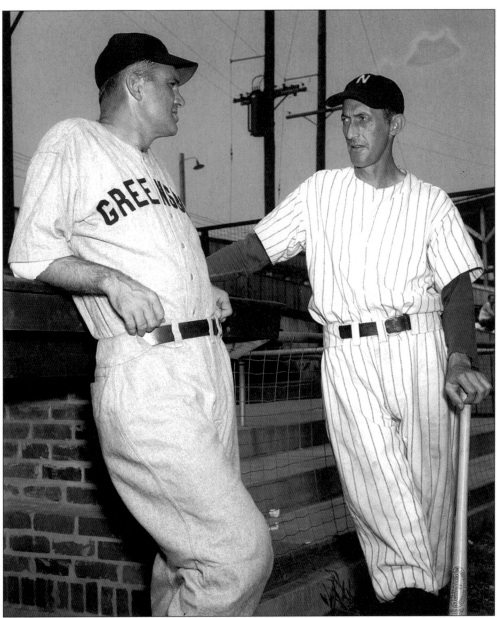

DUGOUT DIALOGUE, 1941. Norfolk pitcher Garland Braxton (right) strikes up a conversation with Greensboro skipper Heinie Manush (left) near the High Rock Park dugout. The two crossed paths earlier in their major league careers as teammates with the 1930 Washington Senators. Despite his retirement from the big leagues in 1939, Manush continued to pencil himself into the lineup and still had the ability to put some ash on the ball as evidenced by a solid .313 average as player-manager for Greensboro in 1941. His illustrious 17-year major league career yielded a lifetime batting average of .330 and earned him a place in the National Baseball Hall of Fame in 1964. Garland Braxton served with a variety of teams from 1921 through 1933 and proved to be an effective starter and reliever. In 1927 he led the American League in game appearances with 58 and saves with 13. The following year he was converted to a starter and led the league with an impressive 2.51 ERA. (NPL.)

YOGI BERRA, A CATCHER IN THE RAW, 1943. Shown lacing up his spikes in the High Rock Park dugout before a game, Tars catcher Yogi Berra flashes a smile to the photographer. On opening day of the 1943 Piedmont League season, Yogi was only 17 years of age and a raw, unproven player in the New York Yankee minor league organization. Yankee brass saw the young catcher as a liability behind the plate with his inconsistent and lackluster defensive skills; however, he quickly established himself as one of the most dangerous and feared power hitters in the league. During the dead ball season of 1943, Berra would finish with 7 home runs, only one behind the Piedmont League leader, teammate Jack Phillips. Veteran Tars catcher Marv Crater switched off with Yogi behind the plate and served as an experienced and patient defensive mentor during his season in Norfolk. (CSTG.)

CHECKING THE LUMBER, 1942. Norfolk Tars batboy Lycurgus McCoy Mitchell Jr. gives the once-over to the array of ash spread in front of the dugout at High Rock Park. Lycurgus was known to be the first on the field to help the groundskeeper and was responsible to make sure that the players had everything they needed for competition. At the time of this photograph the young Tars batboy was attending Bayside Grammar School in Norfolk. (NPL.)

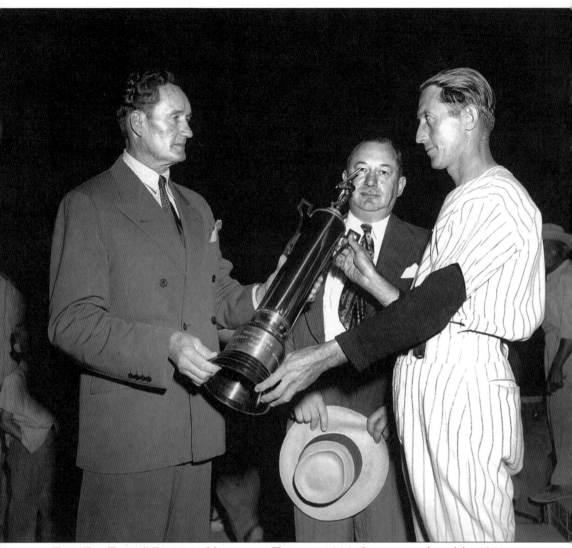

THE "BIG TRAIN" DELIVERS NORFOLK A TROPHY, 1944. On opening day of the 1944 season, Walter "The Big Train" Johnson (left) made an appearance at High Rock Park to present Norfolk manager Garland Braxton (right) with the 1943 Shaughnessy Trophy, won by the Tars for besting the Portsmouth Cubs in the final playoff round. Pictured between Johnson and Braxton is George Weiss, vice president of the New York Yankees and director of their minor league system. Walter Perry Johnson won a total of 416 games over a 21-year major league career as a Washington Senator beginning in 1907. During the 1910 season he posted 25 victories and began an amazing 10-year streak where he won 25 or more games on the mound. His career ended in 1927 when he suffered a broken ankle during spring training. His career stats speak for themselves: 416 victories; 3,508 strikeouts; and 110 shutouts. In 1936, he was honored as part of the legendary group that was inducted into the inaugural class of Baseball's Hall of Fame. After his playing days ended, Johnson managed in the minors and later served as skipper for the Cleveland Indians. Once he hung up his uniform, he returned to his cattle ranch in Maryland. Johnson died of a stroke brought about by a brain tumor at age 59 in 1946, only two years after he presented Norfolk their well-deserved trophy. (NPL.)

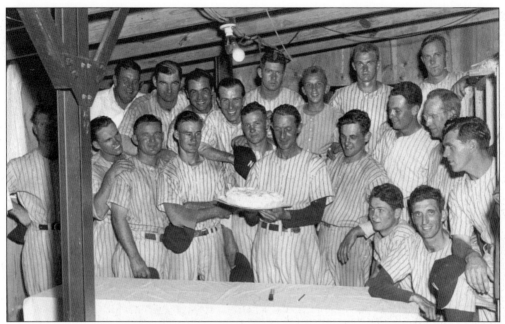

CAKE FOR THE SKIPPER, 1944. Tars player/manager Garland Braxton celebrates his 44th birthday in the Norfolk clubhouse on June 10, 1944, with a cake ordered by his players. Before the game he was showered with gifts from fans including a $25 war bond and a basket of fruit from the press box. Braxton first appeared in the Piedmont League in 1920 with Greensboro and quickly worked his way to the majors, appearing with a number of teams during a big league career that spanned from 1921 until 1933. With the Tars in 1943 he compiled a 14–2 record and an impressive ERA of only 0.72. (NPL.)

NORFOLK AT LYNCHBURG PROGRAM, 1946. A fan at City Stadium in Lynchburg, Virginia purchased this program as the Norfolk Tars challenged the Cardinals in a Piedmont League game played on May 23, 1946. The contest had the special added attraction of Al Schacht, the "Clown Prince Of Baseball," serving as entertainment for the fans and Mr. R.A. Carrington, the reigning president of the league, throwing out the first pitch to start the game. (CSTG.)

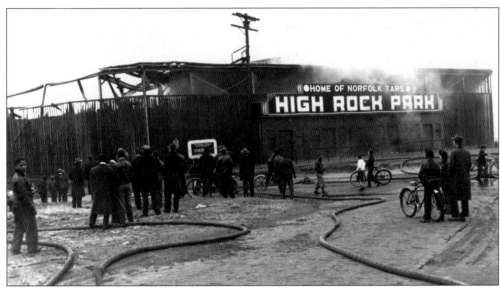

FIRE AT HIGH ROCK PARK, 1944. In the early afternoon of Wednesday, December 27, 1944, "Colonel" H.P. Dawson, the business manager of the Norfolk Tars, was startled to see flames erupting through the left field bleachers of High Rock Park. Local firefighters successfully contained the blaze within hours and saved the ballpark from total devastation. Later investigations revealed the fire was a result of an oil-stove explosion in the park attendant's room. Damage from the inferno gutted the player's locker room, the business manager's office, the concession storeroom, and caused a partial collapse of the press box perched over the third base grandstand. The top photograph shows curious onlookers surveying the damage as smoke continues to plume over the grandstands. The bottom photograph shows the aftermath of the fire to the interior of the ballpark. Owner and local dentist Dr. Eddie Myers immediately restored the park to playing condition with no loss of playing time for the 1945 Piedmont League season. (NPL.)

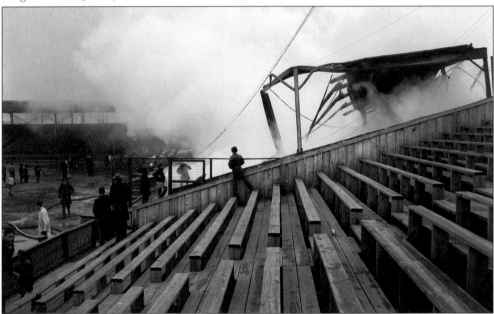

ALLEN "TWO-GUN" GETTEL. After his brief stay with the Tars during the 1943 and 1944 seasons, Al Gettel bounced around the majors with a variety of teams including the Yankees, Indians, White Sox, Senators, and Giants. During the 1943 campaign Gettel would amass a record of 11–11 and an impressive ERA of 1.38, second only to teammate and major league veteran Garland Braxton (0.72). The following season, with his ERA still below two runs per game (1.81), Gettel dominated the Piedmont League with 17 victories and a total of 232 strikeouts. He earned his nickname "Two-Gun" by appearing in a number of movie westerns when he pitched for the Hollywood Stars and Oakland Oaks in the mid-1950s. (From the archives of Allen Gettel.)

A TAR'S FAMILY STROLL IN GHENT. Norfolk Tars right-hander Bob Porterfield is shown walking with his wife, Vera Jean, down the sidewalks of Ghent with their new baby in tow. Porterfield served only briefly with the Tars in 1946 and could only muster a 1–3 record, however by his second year in Norfolk he had Piedmont League batters in the palm of his hand as evidenced by a 17–9 record and 2.37 ERA. He led the league in strikeouts with 208. After his graduation from the Yankees minor league organization, he had his first cup of major league coffee in 1948. Porterfield was traded by New York to the Washington Senators in 1951 and later to the Red Sox in 1955, finishing out his 12-year career with the Chicago Cubs in 1959. (NPL.)

SEVENTH INNING STRETCH AT TAR PARK, 1948. With fans sitting shoulder-to-shoulder in the grandstands during a game at Tar Park, it was always a welcome relief to stand and partake in the ritualized seventh-inning stretch. As early as 1869, Harry Wright reported that Cincinnati Red Stocking fans would rise in the half of the seventh inning to "enjoy the relief afforded by relaxation from a long posture upon hard benches." A more romanticized version of the history of the "stretch" is said to have first taken place on opening day in Washington, D.C. in 1910 when President William Howard Taft lifted his 6-foot 300-pound bulk off his seat in the seventh inning and stretched as the crowd joined in. (NPL.)

TARS MANAGER EARL BOLYARD, 1948. Earl Bolyard is shown here in the Norfolk front office after signing his contract to manage the Tars for the 1948 season. The previous season he led the Twin Falls Cowboys of the Class C Pioneer League to a winning record. However, bringing in Bolyard failed to energize Norfolk and he was replaced by Frank Novosel mid-way through the 1949 campaign. Bolyard played for the Tars during the 1935 season, serving as an outfielder and third baseman when needed. His .327 average was among the Piedmont League's leaders for that year. (NPL.)

NORFOLK BASEBALL NOTES 1940-1949

♦ During spring training of 1940, prospect Eddie Johnson appeared to possess all the skills necessary to procure the third base position on the Tars by opening day. Unfortunately an injury ended his chances to secure a spot on the roster and the young third sacker never suited up with the Tars in a formal game. Few players and fans knew that the disappointed infielder was the son of baseball legend and Hall of Famer Walter Johnson.

♦ On July 29, 1943, three Norfolk Tars vowed to go unshaven until the team won two games in a row. Outfielder Carl McQuillen, first baseman Jack Phillips, and pitcher Bill Sucky discarded their razors until teammates rose to the challenge during the first week of August and won back-to-back games. The rallying call on the team was "Save 'em From The House of David."

♦ In May 1943, when the 17-year-old Yogi Berra was just beginning the season with the Norfolk Tars, the local paper initially had difficulty with his name. In several headlines he was labeled "Berrai" or "Berria" before the media got it right. Interestingly, the local paper did the same thing 43 years earlier with another future Hall of Famer first playing with Norfolk. During the course of the 1900 season Christy Mathewson was known only to fans as "Mathews".

♦ The salary offered Yogi Berra during the 1943 season was meager and he later told friends and family that it was difficult for him to make ends meet over the two weeks he had to stretch his money. In an interview he once mentioned that if Tars fans had not brought sandwiches to the ballpark for him to eat he would have starved to death in Norfolk.

♦ The tense rivalry between the Norfolk Tars and the Portsmouth Cubs continued into the 1940s as was evidenced on July 4, 1944 when the two teams played a unique doubleheader that was filled with fireworks. The early afternoon game was staged in Norfolk with the evening contest scheduled across the Elizabeth River in Portsmouth. A feud erupted during the first game when Tar player George Motto spiked Cub second baseman Roberto Montanes with a late slide. In the nightcap played at Norfolk's High Rock Park, the Cubs retaliated as Lazaro Bernal slid hard and high with spikes flashing into Tars catcher Gene McCready, knocking him senseless. The Tars erupted from the dugout, led by the original culprit of the day, George Motto, and attacked Bernal. The Cuban Cub resorted by swinging freely with a bat to ward off his attackers and a free-for-all ensued before police could restore order. Portsmouth owner Frank D. Lawrence was fond of stocking his team with Cuban players and the local paper stated that several of the Norfolk players were resentful of the foreigners in the lineup.

♦ During a coal shortage in the early part of the 1946 season, Norfolk, Portsmouth, Newport News, and Richmond teams were required to table all night games and reschedule their contests to afternoon or twilight contests. Virginia issued a blackout in the eastern portion of the state, thus denying the clubs from the use of electricity for night baseball for several weeks.

♦ Ed "Whitey" Ford, the young southpaw hurler with the Norfolk Tars, beaned Stuart Martin, manager of the Roanoke Rapids Jays, during an exhibition game on April 19, 1948. Martin, a former major leaguer with the St. Louis Cardinals, was sidelined for 60 days following the incident.

♦ On August 30, 1948 the fans of Newark, New Jersey celebrated Phil Rizzuto Day at Yankee Stadium. "Scooter" was heaped with a number of expensive gifts including a new convertible, golf clubs, a movie projector, and a suit of clothes. Since Norfolk served as a stop for Rizzuto on his way to the Big Apple, the Norfolk Sports Club presented the shortstop with a token of their appreciation: a nine-pound Virginia smoked ham.

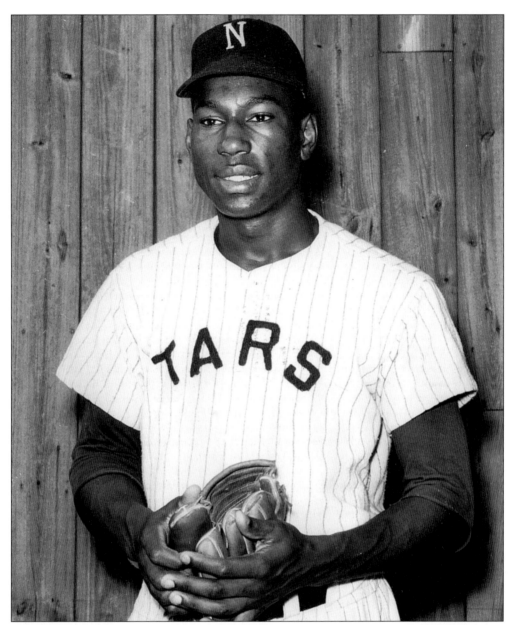

NORFOLK'S FIRST BLACK PLAYER: PITCHER ED ANDREWS, 1954. Norfolk by no means set the stage for the integration of black players in the Piedmont League. The Tars waited almost eight years after Jackie Robinson broke baseball's color barrier before they would issue a Norfolk uniform to a black player. Manager "Skeeter" Scalzi selected young Ed Andrews as his hurler to go against the American League champion Yankees in a scheduled exhibition on April 7, 1954. Andrews, a big, overpowering right-hander from New Brunswick, New Jersey, first played professionally during the 1953 season at Olean where he posted an impressive 11–2 record. In his first start with Norfolk he would perform admirably and hold the visiting Yankees to two singles over the three innings he toiled on the mound at Myers Field. Despite his initial effectiveness, Andrews would pitch with only marginal success during the season, compiling a 5–2 record for the Tars. (VP.)

SEVEN

Black Baseball in Norfolk

It has been said that over the years baseball has been a microcosm of society. Like many cities in the South, this was more than evident in Norfolk, Virginia. From the 1860s, when baseball first appeared, until 1954 when the Tars integrated their team (and more importantly their grandstands) segregation had been a way of life for African Americans. Baseball for the black population of Tidewater has had a long and colorful history that responded to the societal changes of this tumultuous period of the nation.

In 1888, the Norfolk Red Stockings were one of the more popular professional black independent teams in the country, showcasing their skills by barnstorming throughout the South and Northeast. In 1889, a group of enterprising promoters envisioned an idea that professional black baseball teams should have their own tournament and the concept of the "Colored Championship of America" was born. Four of the most renowned black teams of the time were invited to participate in the round-robin tournament, with Norfolk's own Red Stockings selected as part of this elite group. After several days of exciting matches and hard-fought competition, the Cuban Giants were crowned champions followed by the Pittsburgh Keystones, New York Gorhams, and Norfolk. While overmatched in the 1889 tournament, the Norfolk team earned a degree of prominence and respectability throughout the Mid-Atlantic states, and they continued to schedule games on regional diamonds until the early part of the 1900s.

In 1920, another attempt at professional black baseball in the city was initiated with the formation of the Norfolk Stars. The Stars's roster was stocked with a number of players who would go on to have fine careers in the Negro Leagues. Among them were John Cason, Frank Crockett, James Crump, Nap Cummings, Cecil "Sess" Johnson, Jessie "Nip" Winters, Webster McDonald, and Frank Wickware. John Cason, the Stars's catcher, had a career that spanned 15 years with a variety of teams. In 1933, after his playing days ended, Cason would return to Norfolk and manage a popular semi-pro team, the Berkley Black Sox, for several years. Red Stockings first baseman Nap Cummings played 11 of his 14 years for the Atlantic City Bacharach Giants, a legendary team that dominated the Eastern Colored League. Jessie "Nip" Winters, a southpaw for the Stars, would spend two years in Norfolk and was later regarded as one of the best pitchers for Hilldale of the Eastern Colored League. Webster McDonald would go on to have a successful 20-year Negro League career as both a pitcher and manager following his early days in Norfolk.

In 1921 a new team emerged in the city that stocked its roster with key players from the 1920 Stars. The Norfolk Giants convinced James Crump, Cecil Johnson, and Jessie "Nip" Winters to change uniforms for the upcoming season. Other black players such as Holsey "Script" Lee and George "Chappie" Johnson were convinced to come to Norfolk and play for the Giants for the 1921 season. "Script" Lee was a strong-armed, right-handed hurler with an illustrious career with Hilldale, the 1923, 1924, and 1925 Eastern Colored League Champions. "Chappie" Johnson served as player-manager for Norfolk and had earned a reputation as an accomplished and experienced catcher for some of black baseball's most notable teams during the first 20 years of the century, including the Page Fence Giants, Cuban X-Giants, Leland Giants, Brooklyn Royal Giants, and the Mohawk Giants. His career would

extend until 1939, serving as manager throughout black baseball for a number of teams. Despite a storied roster, the Norfolk Giants struggled on the field and dissolved in July of 1921.

For approximately the next 35 years, barnstorming Negro League teams and many excellent semi-pro teams in the Tidewater area would try to fill Norfolk's thirst for black baseball. Local and regional teams such as the Olney Giants, Lambert Point Slides, Portsmouth Firefighters, Tittustown Trojans, Berkley Black Sox, Portsmouth Revels, Portsmouth Eagles, Belleview Grays, and Suffolk Aces played on fields throughout the area. None was more popular than the Battling Palms, described in the Journal and Guide, Norfolk's premier black paper, as "one of the pioneering clubs on the black baseball front." The team was sponsored by the Palm Leaf Athletic Association and for more than 30 years was recognized as one of the most successful black semi-pro teams in the South. For nearly 13 years the Palms played at Norfolk's Community Field, located near Booker T. Washington High School. The field, built and maintained by the Palms, would also serve as the home for Norfolk State College and Booker T. Washington High School gridiron matches until its closure in 1955. In 1954, the Indianapolis Clowns, managed by Negro League great Oscar Charleston, held its spring training in Norfolk at Community Field.

Negro League teams made regular visits to Norfolk, Portsmouth, and Newport News to play both exhibition and scheduled league games for local baseball fans. In 1921, only eight weeks after the Norfolk Giants had disbanded, the popular Bacharach Giants of New York and the Indianapolis ABCs treated Norfolk fans to a two-day visit filled with highly competitive and interesting games. Norfolk would prove a popular destination for Negro League teams for the next 34 years. Staging contests at League Park, Bain Field, and Myers Field when the Norfolk Tars were out of town, fans of the game filled the stands to watch Negro League teams and their exciting brand of baseball. The New York Cubans, Philadelphia Stars, Baltimore Black Sox, and New York Black Yankees were some of the teams who put Norfolk on their barnstorming schedule. However none could create as much anticipation with the local baseball fan as the powerful Homestead Grays and Newark Eagles. These teams often arranged series of games with a variety of opponents on diamonds in Norfolk and Portsmouth. Area fans were treated with the prowess of future Baseball Hall of Fame members Smokey Joe Williams, Josh Gibson, Buck Leonard, Leon Day, Ray Dandridge, Willie Wells, Monte Irvin, and Larry Doby. The spectators that filled the stands to watch these legendary performers proved to be both black and white, for all area fans were adept at recognizing good baseball.

Until 1954, Norfolk was seen as one of the most segregated baseball cities in the minor leagues. African-American fans that supported the Norfolk Tars over the years regularly faced discrimination while at the ballpark. Black patrons were required to enter through a designated "Jim Crow" gate and sit in the "colored grandstand," a small, poorly covered bleacher section near third base, or the "colored bleachers" along left field. The grandstands at nearby Portsmouth Stadium and War Memorial Stadium in Newport News had been desegregated several years before the Tars would remove the seating restrictions at Myers Field. Norfolk's black fans, upset by the continued seating restrictions of the Tars as well as the Yankees' failure to integrate the team, decided to boycott games staged at Myers Field. During the 1953 season, black fans traveled across the river to Portsmouth and supported Frank D. Lawrence's Merrimacs, who had several African Americans on the team and a grandstand and bleachers open to everyone. Attendance at Norfolk home games dropped significantly during the 1953 season despite a pennant-winning team. In 1954 the Yankees relinquished their ownership of the Tars to a group of local investors who immediately integrated the Tars's roster and opened the grandstand and bleachers to all patrons. Despite the improvements for black fans and new opportunities for black players, the changes were too little too late, as the Tars would close the gates at Myers Field in July 1955.

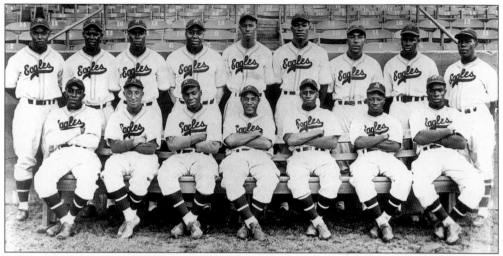

NEWARK EAGLES, 1939. Pictured here is a team photograph of the 1939 Newark Eagles of the Negro National League. The team featured a number of prominent players including Monte Irvin, Mule Suttles, Max Manning, Leon Day, Dick Seay, Dick Lundy, Willie Wells, and Leon Ruffin. Ruffin was a familiar face to Norfolk fans since he had previously played semi-pro ball for a number of black teams in the area. During a visit to Norfolk in 1939, Mule Suttles showcased some of his renowned power by hitting three tremendous home runs over the Bain Field fences in front of 2,400 fans. The Eagles were frequent and popular visitors to Norfolk during the days of segregated baseball. (From the collection of Todd Bolton.)

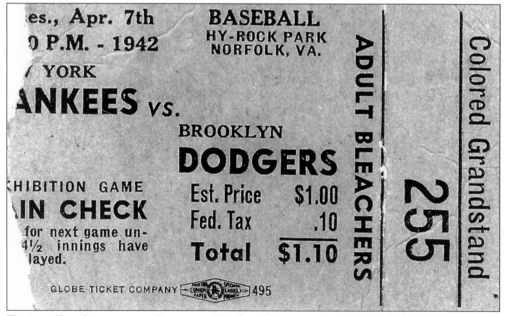

TICKETS FOR SEGREGATED BASEBALL. Displayed here is a rare ticket stub for entrance to the "Colored Grandstand" at High Rock Park for a 1942 exhibition between the New York Yankees and Brooklyn Dodgers. African-American patrons were required to sit and watch the game from a cordoned-off portion of the bleachers in left field. These fans would often have to wait to gain entrance to the park through the single "Jim-Crow" gate, while "white only" turnstiles were devoid of patrons. (From the collection of Ron Pomfrey.)

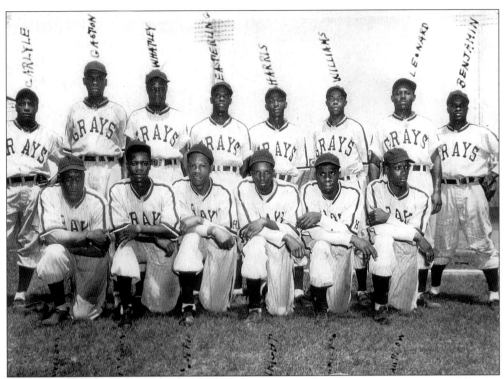

THE HOMESTEAD GRAYS, 1941. Of all the teams in the Negro Leagues, few could match the power and prestige of the Homestead Grays. The Grays proved to be the most dominant of all black teams from 1937 until 1948, winning nine league championships. This 1941 team featured such legends as Jud Wilson, Vic Harris, Ray Brown, Terris McDuffie, and future baseball Hall of Famer Walter "Buck" Leonard. During their 1941 visit to Norfolk, the Grays earned a 3–1 victory over the New York Cubans as first baseman Buck Leonard slammed a home run and put on a dazzling defensive show for the appreciative fans. (From the collection of Jeff Eastland.)

GRAYS VS. BLACK YANKEES AD, 1945. Shown here is one of many classic advertisements promoting baseball as featured in the *Norfolk Journal and Guide*. The *Guide* was one of the premier African-American newspapers in the country and was renowned for its sports coverage, featuring the insightful writings of editors E.B. Rey, Lem Graves, and Cal Jacox. The ads featured many of the top Negro League teams of the era and were designed to entice fans to area ballparks. (NPL.)

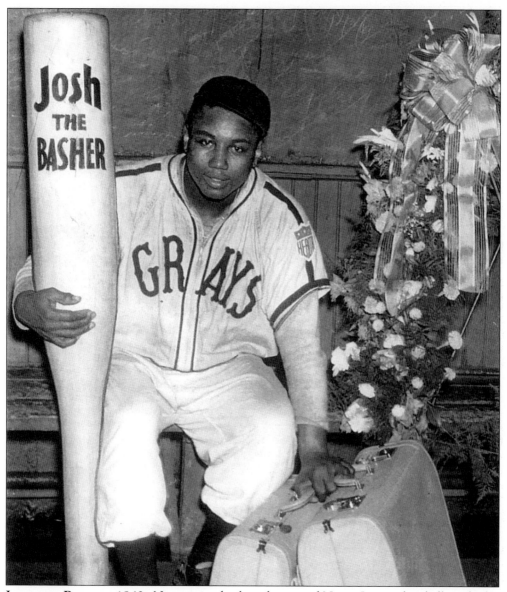

JOSH THE BASHER, 1943. No one in the long history of Negro League baseball, with the possible exception of Satchel Paige, could cause more excitement in a ballpark than slugger Josh Gibson. His popularity with African-American fans is legendary and he was often called the "Black Babe Ruth" for his towering, explosive home runs. Shown here in a rarely published photograph, Gibson leans against a large bat that proclaims him as "Josh The Basher." A frequent visitor to Norfolk's Bain Field and High Rock Park, local fans were treated to yearly exhibitions of his power as he consistently sent rockets over the outfield walls. In the prime of his career at age 33, he was diagnosed with a brain tumor after suffering a series of headaches and blackouts. Unwilling to undergo an operation that may have improved his condition, Josh returned to the diamond and continued to dominate the league until his skills began to deteriorate in 1946. He suffered a stroke that proved to be fatal only a few weeks after his 35th birthday. Josh Gibson was inducted into the 1972 class of the Baseball Hall of Fame along with longtime teammate Buck Leonard. (From the personal collection of Jeff Eastland.)

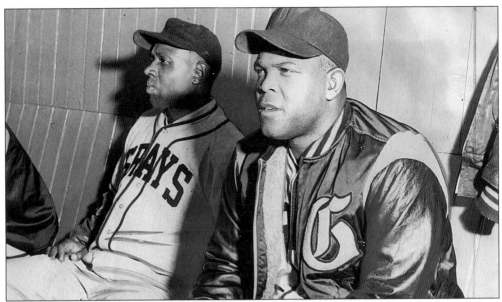

BUCK LEONARD AND TOM PARKER, 1948. Pictured in the dugout of the Homestead Grays are first baseman Walter "Buck" Leonard (back) and pitcher Tom Parker (foreground), players on the 1948 Negro World Series Championship team. The Grays were frequent visitors to both Norfolk and Portsmouth and never failed to fill area stadiums with appreciative fans. At the time of this photo, the 41-year-old Leonard led the Negro Leagues in several offensive categories including home runs and batting. (CSTG.)

Benefit of THE BATTLING PALMS - 1954 Season

BATTLING PALMS

VS

NORFOLK TARS

MYERS FIELD - Saturday, April 17th, 8:00 p.m.

Nº 2151

In the event of rain on April 17th, game will be played on Monday, April 19th, 8:00 p. m.

CONTRIBUTION . . $1.00

TARS VS. PALMS TICKET, 1954. This ticket was purchased by a Norfolk fan to attend a preseason game at Myers Field on Saturday, April 17, 1954 between the Norfolk Tars and the Battling Palms. With the opening of the stands to all patrons in the 1954 season, this ticket was one of the first that did not restrict African-American fans from sitting anywhere throughout the ballpark. (CSTG.)

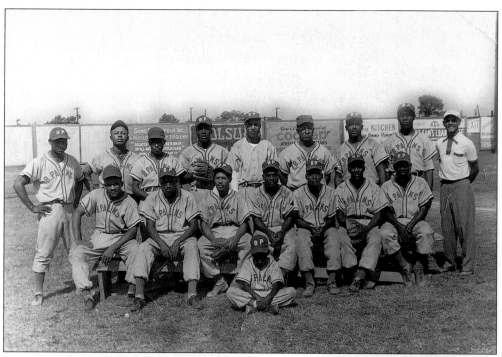

NORFOLK'S BATTLING PALMS, 1952. This team photograph of the Battling Palms was taken at Norfolk's Community Field, located two blocks from the old Booker T. Washington High School. The field provided black patrons a baseball facility that was not restricted to the segregated regulations of Myers Field. For nearly 13 years Community Field showcased visits by local black semi-pro clubs and visiting Negro League teams. As seen in the adjacent *Journal and Guide* advertisement, white barnstorming major league teams were at times invited to stage exhibitions against the Palms. Clyde McCullough, Norfolk resident and Chicago Cubs catcher, managed a team of major and minor league players that challenged the Palms in the fall of 1953. Featured among the players were Washington Senators pitchers Bob Porterfield and Chuck Stobbs. Interestingly, the Palms added Portsmouth Merrimacs star Charlie "Mule" Peete and a young Willie Mays, who was serving a tour of duty in the Army at Fort Eustis, Virginia. The Palms's last year of operation came in 1955 when the Community Field land was sold to a developer and a suitable venue to continue play in 1956 could not be secured. (From the archives of Thomas Burt.)

BASEBALL!

★ ★ ★ ★ ★ ★

CLYDE McCULLOUGHS
Major League

ALL - STARS

vs.

BATTLING PALMS

Featuring BOB PORTERFIELD
(Pitcher)
Featuring WILLIE MAYS
and "Mule" PETE

SUN., OCT. 25th

Community Field

Game Time: 2:30 P. M.

Advance Tickets ----------------$1.00
Admission at Gate -----------$1.25

NORFOLK TARS MANAGER MAYO SMITH, 1951–1952. The skipper of the Tars, 37-year-old Edward Mayo Smith, stands proudly on the steps of the Norfolk dugout at Myers Field in this 1952 photograph. Smith first broke into organized baseball in 1935, toiled a decade in the minors, and finally made it to the majors for 73 games with the Philadelphia Athletics in 1945. He finished out his playing career with Portland of the Pacific Coast League and began managing in the New York Yankee organization in 1949. He quickly moved up the franchise chain and found himself with the Norfolk Tars for the 1951 season. Smith would prove to be the Tars's most successful manager in the history of the franchise, as he compiled a record of 177 victories against only 94 losses. His two-year tenure with Norfolk culminated in back-to-back Piedmont League pennants. He served as manager for the Phillies from 1955 to 1958 and earned his greatest managerial achievement in 1968, when he led the Detroit Tigers to the World Series and a legendary come-from-behind victory over the St. Louis Cardinals. (NPL)

EIGHT

Dominance and Demise

in the Piedmont League

The Norfolk Tars, as well as their fans, must have been relieved to see the 1940s come to an end. From the turbulent war years to the exuberant seasons following the allied victory, Norfolk could manage to attach only one Piedmont League championship pennant to the lanyards of the flagpole at Tar Park. The parent club in New York and the Tars administration longed for the winning traditions established in the 1930s. As the decade of McCarthyism, economic prosperity, and televised sports events began, the Tars almost immediately initiated a reign of dominance unmatched in Piedmont League history. With their Elizabeth River rivals, the Portsmouth Cubs, capturing the first league pennant of the decade, the Tars soon ran off an impressive streak of four consecutive championship seasons from 1951 through 1954.

The 1950 season began as the 1949 season ended, with uninspired play and too many losses. The re-hiring of manager Frank Novosel seemed to send a message to Tars fans and players that the Yankees were less than motivated to produce a winning ballclub. The saving grace for the 1950 team continued to be Tar mainstay Miff Davidson, who again had a great year with 21 home runs and 85 RBIs. On the mound the team lacked any depth with only future Yankee Al Cicotte managing a winning record, posting 15 victories against 12 defeats. The fans continued to support the team as over 93,000 passed through the turnstiles of Myers Field, but it was a significant decrease from the previous season when more than 140,000 watched the hapless Tars.

George Weiss, Jack Ruppert, and the rest of the New York brass knew that something had to be done to pump new talent and managerial leadership into the Norfolk franchise. Weiss searched throughout the minor league system during the off-season, found veteran Mayo Smith, and selected him as the new skipper for the Tars. The New York scouts began to funnel some impressive talent into Norfolk, including a couple of future major leaguers that would figure prominently in the outcome of the 1951 season. Outfielder Bill Virdon played like a gazelle in his centerfield position and Bill "Moose" Skowron began his career as a left fielder at Myers Field in the days before he would become the everyday Yankees first baseman. With Miff Davidson and Lou Skizas sharing duties in right field, the Tars had one of the most dominant and agile outfields in the Piedmont League. This group of outfielders drew so much attention for their offensive and defensive deeds that The Sporting News assigned a reporter to do nothing more than follow the Tars and report on their exploits. It took Norfolk and its manager the first half of the 1951 season before the team matured and sprang into first place, overtaking the Portsmouth Cubs and then staving off a late-season ambush by the Richmond Colts. As the last pitch of the regular season settled into catcher George Menard's mitt, the Tars found themselves with their first Piedmont League pennant since 1945. The end of season momentum carried them through the Shaughnessy Playoffs as they punished first Portsmouth and then Richmond in the postseason. Manager Mayo Smith had turned the Norfolk franchise around with effective leadership and a bevy of talented players. "Moose" Skowron would top the league with a .334 average and earn MVP honors for batting. A number of pitchers won more than 10 games, with Don Bessent almost unbeatable with an 11–2 record. Tars hurler John Gray was unable to post a winning record but led the league in strikeouts

with 192. With the success on the field, Norfolk's faithful filled the seats as almost 105,000 passed through the turnstiles at Myers Field.

As would be expected, Mayo Smith was retained for the upcoming season, a year that many consider the acme in the history of the Tars. Yet 1952 would also be the beginning of the end for the Norfolk Tars and ultimately the Piedmont League as well. As the season unfolded, attendance throughout minor league baseball plummeted. During the post-war years the minors flourished with 59 professional leagues encompassing over 400 cities; however as the 1952 season began the number would dwindle to less than 45 leagues. By 1956 there would be only 27 surviving leagues and in 1959 the number evaporated to a minuscule 21. All told, the number of minor leagues had been sliced in half in less than a decade. As the 1950s progressed, fans found that baseball was less a necessity and more an afterthought. Television was king and the citizens of Norfolk spent many of their evenings glued to the tube, which left little time to take in a Tars game at Myers Field. Owners throughout the Piedmont League watched as attendance dropped and fewer fans filled the grandstands. Things went from bad to worse with the sudden dominance of the Norfolk ball club, resulting in many cities of the tobacco league frustrated at their inability to field a team that could challenge the Tars. Surprisingly, as continuous pennants were raised in Norfolk, the local fans became complacent, taking for granted the winning ways of their home team and not finding the desire or need to support them.

Despite these serious developments, manager Mayo Smith's Tars started the 1952 season as a force to be reckoned with and soon outdistanced any and all contenders. When the season ended, the Tars found themselves a staggering 26 1/2 games up on the Portsmouth Cubs. Norfolk again was full of offensive stars including Dick Tettlebach, Bill Casanova, Wally Lance, and Woodie Held. The mound corps proved to be a premier group with Charlie LeBrun winning 23 games and future Yankee Johnny Kucks tallying 19 victories. With such a dominating lead, the Tars coasted to the Piedmont League pennant but found themselves suddenly ambushed by the Richmond Colts in the playoffs. While the postseason ended on a sour note, the 1952 Norfolk Tars are still considered one of the finest teams in minor league history.

With Mayo Smith being promoted to skipper of the Birmingham Barons for the 1953 season, New York pulled a grizzled veteran from the major league ranks to manage the Tars. Catcher Mickey Owen hung up his big league spikes after the 1951 season having served 12 years with a number of teams. Owen would prove to be a scrappy player/manager for the Tars, driving Norfolk to yet another Piedmont pennant and domination in the post-season playoffs. The offensive star for the 1953 Tars proved to be young Jerry Lynch, who led almost all offensive categories in the league, and then captured the MVP award for his exploits. Lynch did it all as he cracked 21 home runs, drove in 133 runs, and slugged an impressive .333 average while dominating the league in doubles and triples. The Yankee scouts continued to discover great arms for the Tars with Lloyd Merritt winning 20 games and Wilson Parsons 15 as he posted a league-leading ERA of 2.04. The unbridled success of the Tars, the explosion of television, and a boycott by black patrons contributed to the erosion of the fan base coming to Myers Field, as fewer than 70,000 filled the bleachers.

Despite his success with the Tars in 1953, manager Owen could not refuse the offer by the Boston Red Sox to strap on his catching gear for the 1954 season and serve as a reliable backup for first-string catcher Sammy White. Meanwhile, the Tars would continue their winning ways under new skipper, Frank "Skeeter" Scalzi. With the Yankees selling ownership of the franchise to a local group of investors during the off-season, the 20-year relationship between the New York organization and Norfolk came to an end. The community rallied around the new owners and a dramatic increase in attendance resulted, with almost twice as many fans watching the 1954 Tars as compared with the previous season. It didn't seem to matter who was overseeing the team or wearing the Norfolk pinstripes, for the results continued to be the same: another Piedmont League season dominated by the Tars. With first baseman Danny Keith providing the firepower from the plate and hurlers Jim Coates, Paul Doughty, Ozzie Grasso, and Ken Beardslee working miracles on the mound, Norfolk again found itself in first place at the conclusion of the season. But as had happened two years prior, the Tars were surprised in the postseason and quickly eliminated in the first round of the playoffs.

The 1955 season began with optimism from the fans and the Tars administration, as everyone predicted that still another pennant was in the future. Veteran major league catcher Al Evans took over for Skeeter Scalzi but immediately experienced difficulty pushing the Tars out of the second division during the season's initial months. With losses mounting in the standings and in the cash box, the Norfolk investors demanded Evans's resignation, but the players came close to a mutiny over the situation and tried to convince their skipper to stay on. Evans was ultimately fired and replaced by Tars pitcher Alton Brown, a local native and fan favorite, as interim manager. After some speculation that Scalzi would return to the fold, the media was informed that general manager Bill Herring would take over the reigns of the team. The turmoil in the clubhouse, open bickering to the media, and poor performance on the diamond contributed to a precipitous drop in attendance at Myers Field. During the month of June the Tars attempted to bolster fan support with more aggressive advertising, as well as novel promotions including giving away a car and trips to New York City for paying fans. Ticket prices were slashed with little improvement in attendance. On one occasion, the investors brought in television sets and mounted them on support beams in the grandstands so that the fans would not miss a much-ballyhooed heavyweight boxing match that threatened to keep the seats of Myers empty.

All the effort was for naught. The Norfolk fans were informed that the final game of the season would be on July 13th against the Sunbury Redlegs. Despite the black cloud of impending doom hanging over the players, the Tars completed their last official Piedmont League game with an 11–3 victory in front of less than 1,000 fans. Shortly after 10 p.m., the groundskeeper extinguished the lights at Myers Field and the game of baseball vacated the city of Norfolk until 1970.

ALTON BROWN AND SKEETER SCALZI, 1954. Norfolk native Al Brown shows Tars manager Skeeter Scalzi the grip he used to dominate opposing batters over the 1954 Piedmont League season. Scalzi made no qualms that the Tars won the pennant in 1954 with Al Brown's strong mound work. Records for the season reveal that Brown won 14 games and lost 6, with Scalzi crediting the big right-hander with saving nearly 15 games during the campaign. (VP.)

"MIFF" DAVIDSON, TARS RIGHT FIELDER, 1949–1951. Crawford "Miff" Davidson proved to be one of the most prolific hitters in the Piedmont League during his seven-year minor league career. From 1949 until the league's demise in 1955, "Miff" slugged a total of 124 home runs, 567 RBIs, 897 accumulated hits, and scored 558 runs. He first donned a Norfolk uniform in 1949 and generated a .304 batting average followed by a banner year in 1950 when he hit 21 homers, 85 RBIs, and led the league in total bases with 242. For his efforts he was named to the Piedmont League All-Star team. In 1951 he was platooned in right field with Lou Skizas and was part of the famous Norfolk outfield consisting of future major leaguers "Moose" Skowron and Bill Virdon. The offensive power generated by the Tars's outfield brought intense media coverage with *The Sporting News* often reporting on their progress during the course of the season. Davidson left the Tars after the 1951 season and completed his Piedmont League career with the Lynchburg Cardinals in 1952 and 1953, followed by two years with the Hagerstown Packets until 1955. Davidson continued to display gaudy offense numbers in a rival uniform and the Tars regretted allowing this husky, power-hitting All-Star to escape their grasp. (VP.)

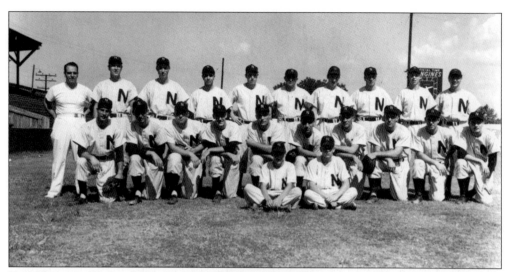

THE NORFOLK TARS, 1950. The Norfolk franchise would continue to meander along in the second division of the Piedmont League and was lucky to finish in fifth place, just ahead of the Newport News Dodgers, as the 1950 season ended. Few bright spots could be found with the Tars of 1950; however outfielder Miff Davidson continued to impress fans with solid offensive numbers. Joining Davidson in the outfield was Bill Renna and Pete Gentile. The infield consisted of Don Reimer, Orlin Martin, John Wilkinson, George Prigge, Jim Finigan, and Elder Haapala. The mound corps were directed by George Menard with veteran catcher Marv Crater serving as his back-up. Al Ciccotte led the team with 15 wins and Bob Grim contributed another 10 victories for the Tars. The rest of the hurlers included Pete Vucurevich, Jack Widner, John Moore, Bill Maroney, Del Owens, and Bill John. The team is pictured here on the outfield grass of Myers Field in the spring of 1950. (NPL.)

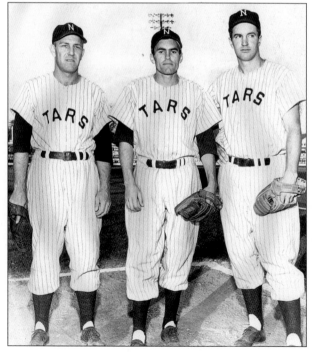

BRAINTRUST OF THE 1951 TARS. These three mainstays of the 1951 Piedmont League champion Norfolk Tars were veterans of the college ranks before they entered into professional baseball. First baseman Wally Lance (left) was a graduate of Tennessee State Teachers College, Johnny Hunton (center) graduated from the University of Maryland, and Dick Tettlebach (right) was a Yale University alumnus. Each contributed brawn and brains during an impressive 1951 season as Norfolk finished 4 1/2 games ahead of the Richmond Colts and defeated Portsmouth and Richmond in the Shaughnessy Playoffs. (VP.)

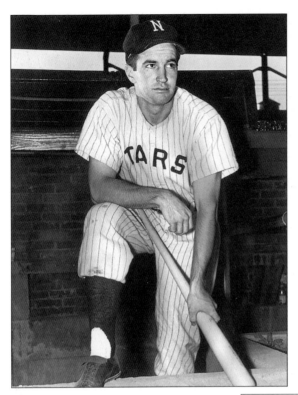

TAR SPEEDSTER DICK TETTLEBACH, 1952. Centerfielder Dick "Tut" Tettlebach provided all the necessary speed the legendary 1952 Norfolk Tars would ever need. He led the league in stolen bases (30) and tied for the lead in triples (8). At the plate he batted a respectable .317 with 6 home runs and 85 RBIs. His totals earned him a place on the 1952 Piedmont League All-Star team. "Tut" would make it to the New York Yankees in 1955 but only appeared in two games with five at-bats. On February 8, 1956, he was traded by the Yankees to the Washington Senators along with Whitey Herzog and three other players. The Senators took advantage of his speed but limited his play to only 18 games in 1956. Despite his restricted play, Tettlebach was still able to manage 15 stolen bases for the season. His final year in the majors came in 1957 with Washington. (VP.)

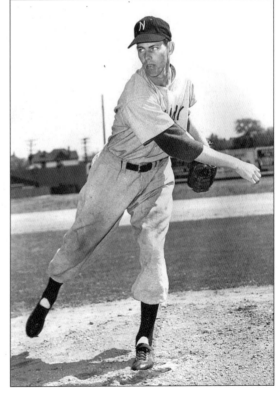

CHARLIE LeBRUN, 1952. The 1952 Norfolk Tars proved to be one of the most powerful teams in minor league history as they finished an amazing 26 1/2 games in front of their closest rival in the Piedmont League. Their 96–37 record was attained by a team that had both dynamic hitters and the strongest pitching staff in the league. Without a doubt the ace of the Tars proved to be right-hander Charlie LeBrun. A former Red Sox farmhand, LeBrun won 23 games against only 4 defeats. The Tars could always count on a full house at Myers Field when he was scheduled to pitch. LeBrun's ERA was a minuscule 1.87 and for his exploits on the slab he was selected to the Piedmont League All-Star team. He finished a close second to Portsmouth's Kenny Guettler for MVP honors for the season. (VP.)

JOHNNY KUCKS, A YANKEE HERO IN THE MAKING. As a tall, lanky 19-year-old right-hander, Johnny Kucks proved to be one of the driving forces behind the legendary 1952 Norfolk Tars team. His 19–6 record took the Tars to the Piedmont League pennant and earned him All-Star status along with fellow pitching mate Charlie LeBrun. Kucks would continue to work his way through the Yankees organization over the next several seasons and finally earn a spot with the Bronx Bombers in 1955, when he recorded 8 victories against 7 defeats. His banner year in the majors came in 1956 when he posted an impressive 18–9 record with a 3.85 ERA. While Don Larsen grabbed most of the media's attention with his perfect game in the fifth contest of the 1956 World Series, it was Johnny Kucks who pitched a masterful nine-inning seventh game holding the Brooklyn Dodgers to only 3 hits as the Yankees won the title. Interestingly, the power needed for the final game victory came from two former Norfolk Tars as Yogi Berra hit a pair of two-run homers and Moose Skowron belted a seventh inning grand slam. Johnny Kucks would remain with the Yankees until 1959 when he was traded along with another former World Series hero, Tom Sturdivant, to Kansas City. He would finish his major league career with the Athletics in 1960. (VP.)

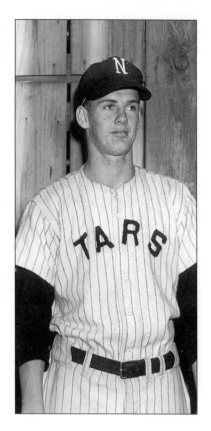

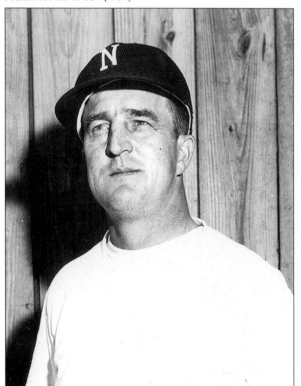

"FRECKLES" FIRCHIR, TARS TRAINER, 1953. Pictured here in his standard attire of a white T-shirt and Norfolk baseball cap, Johnny "Freckles" Firchir poses for the camera at Myers Field in this 1953 photo. Firchir traded positions with former Tars trainer Joe Soares, who left Norfolk to fill the position with the Binghamton Triplets in the Eastern League. Firchir promised Norfolk fans, in a quote recorded on the pages of the *Virginian-Pilot*, that "I am confident I can keep the Tars in condition for the Piedmont League pennant race." Firchir was true to his word as the Tars captured the league title for a third straight year. (VP.)

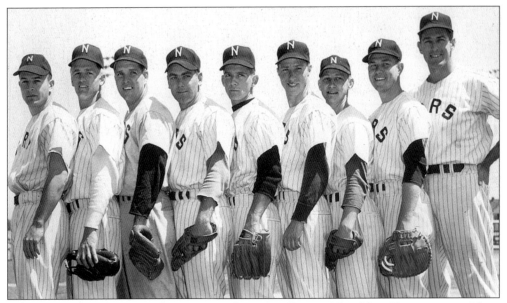

NORFOLK TARS STARTING LINEUP FOR OPENING DAY, 1951. New Tars manager Mayo Smith announced his opening day lineup on April 20, 1951. Here the Norfolk nine proudly poses for the photographer on the grass of Myers Field. Pictured from left to right are Dave Krigs (LF), Dorrel "Whitey" Herzog (CF), George Gasser (2B), Les Taylor (RF), Buddy Carter (3B), Don Reimer (1B), Ray Clark (SS), Marv Crater (C), and pitcher Johnny Gray. Despite manager Smith's opening day selections, the 1951 team looked quite different by the end of the season. Future major league player and manager "Whitey" Herzog was quickly replaced by another future big league star, Bill Virdon, and Bill "Moose" Skowron soon won the left field position from Dave Krigs. (VP.)

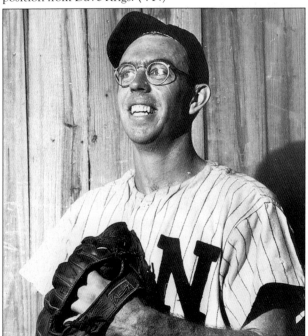

HAPPY HERBIE PLEWS, 1953. No one on the Tars could exude as much enjoyment and excitement for the game than second baseman Herbie Plews, as witnessed in this photograph taken at Myers Field. During the 1953 season Plews served as the starting second sacker for Mickey Owen's champion Piedmont League Tars and contributed a .304 batting average at the plate. In 1956 he earned a spot with the Washington Senators and finished his career with the Boston Red Sox in 1959. (VP.)

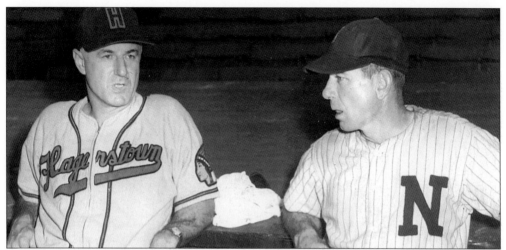

Two Major League Veterans Talk it Over, 1953. Seen in the dugout before a Piedmont League game in 1953, Hagerstown manager Bill Jurges and Norfolk skipper Mickey Owen are perhaps rehashing memories of their time in the major leagues. Jurges broke in with the Chicago Cubs in 1931 and quickly became their starting shortstop through the 1938 season. He returned to the Cubs for the 1946–1947 seasons after spending time with the New York Giants. In a 1932 scenario not unlike the movie *The Natural*, a love-crazed female fan phoned Jurges in his hotel and entered the room with intentions of suicide. He attempted to stop the woman from killing herself and in the scuffle took a bullet in the hand and ribs. Tars catcher and manager Mickey Owen, also a veteran of the big time, started out with the Cardinals in 1937. He was sent to the Brooklyn Dodgers in 1941 and will be forever immortalized for allowing a passed ball on Yankee Tommy Heinrich in the fourth game of the 1941 World Series. With no Yankees aboard and Heinrich looking at a called third strike that would have ended the game, the ball clipped Owen's mitt and the expected last out trotted to first. The Yankees came back with four runs in the inning and took a commanding three-to-one game lead. They would finish off the Dodgers the following night. (VP.)

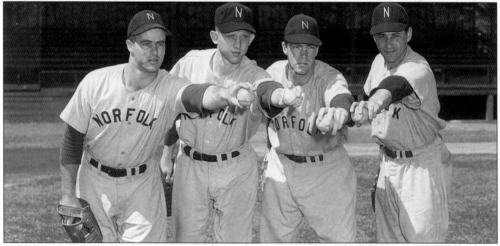

Southpaw Hopefuls, 1954. Shown here in front of the bleachers of Riley Park, the spring training facility for the Tars in 1954, are four left-handed hurlers hoping to make the final cut before heading home to Myers Field. The Norfolk Tars used the Charleston, South Carolina facility as their pre-season training site off and on beginning in the early 1940s. (VP.)

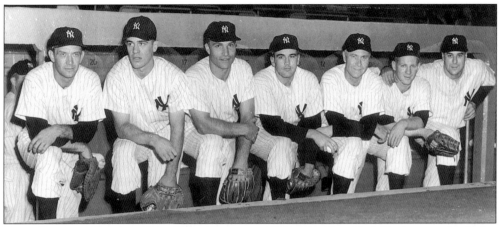

FROM NORFOLK TARS TO NEW YORK YANKEES, 1953. The New York Yankees established a working affiliation with the Norfolk Tars beginning in 1934 and continued the partnership until the 1954 season. Over the years many a young Tar would prove himself in Norfolk and earn the right to wear the pinstripes of the Yankees, thus becoming part of the American League's most powerful franchise. As seen above, the following Yankee legends called Norfolk home during their years in the minors: (from left to right) first baseman Joe Collins (1942), catcher Gus Triandos (1949), outfielder Bill Renna (1950), pitcher Tom Gorman (1946–47), pitcher Jim Turner (1928), pitcher Whitey Ford (1948), and pitcher Vic Raschi (1942). (VP.)

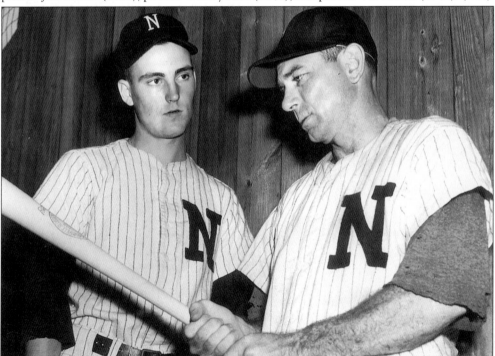

LISTENING TO EXPERIENCE, 1953. New Norfolk manager Mickey Owen discusses his batting grip with a young Dick Sanders, the starting shortstop for the 1953 Tars. While Tars outfielder Jerry Lynch was the offensive dynamo for the team that season, Sanders proved to be a reliable infielder with good hands and power at the plate. He boasted 12 home runs, 68 RBIs, and a .276 average over the course of the campaign. (VP.)

TARS CONTRACT, 1954. In the spring of 1954, Roy Dessinger, general manager for the Tars, offered his veteran pitcher Al Brown a contract for the upcoming season. The initial offering of $250 did not suit Brown's expectations since he had just contributed an 11–9 record and proved to be an important asset in the team capturing the Piedmont League pennant. After spirited negotiations, Brown and Dessinger agreed on a figure of $375 per month. Interestingly, the Norfolk pitcher was paid an additional $50 "for driving the club station wagon and transporting players" to and from road trips. (From the archives of Alton Brown.)

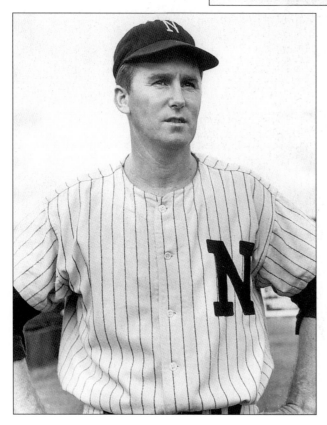

AL BROWN, 1953–1955. Alton Brown, born and raised in Norfolk, remembers working the scoreboard at Bain Field as a youth. He never played organized baseball until he joined the Army during World War II. Following the service he continued as a pitcher locally in the Norfolk city league and began his pro career in 1948 with Roanoke Rapids in the Coastal Plains League. In 1950 he went 28–11 and was voted MVP of the league. In 1951 he made the jump from Class D ball to the opening day roster of the Washington Senators, pitching in seven games before being sent to Chattanooga. Brown was a mainstay with Norfolk from 1953 until they folded in 1955. (VP.)

Tars Right-hander Jim Coates, 1954. James Alton Coates made his first appearance with the Norfolk Tars in 1954 and helped propel the team to its fourth (and final) Piedmont League pennant in a row. The lanky right-hander tallied a 9–6 record and struck out 144 batters during the season. The six-foot four-inch hurler made it to the majors with the Yankees in 1956 but proved to be less than effective in two relief appearances. Coates again returned to the Bronx Bombers in 1959 and stuck with the team through the 1962 season. Big Jim was noted for his serious demeanor on the mound and refusal to allow a batter to get the best of him. Never one to hold back on sending a message to opposing batters, he once hit Boston Red Sox eccentric Jimmy Piersall even before he stepped to the plate. As Coates was warming up following a call from manager Casey Stengel to take the mound, Piersall was arrogantly swinging four bats near the plate before stepping into the box. Coates threw his last warm-up pitch and smacked the surprised Red Sox outfielder squarely with the ball. Over a productive nine-year major league career spent with the New York Yankees, Washington Senators, Cincinnati Reds, and California Angels, Coates accumulated 43 victories against only 22 losses for a .662 winning percentage. His most impressive years came from 1959 through 1962 while with the Yankees, posting winning records each season. Jim Coates retired from baseball in 1967 at the age of 35. (VP.)

Jim Coates's Norfolk Tars Payroll Check, 1954. Jim Coates, the Tars's tall right-handed hurler, cashed this check two days after its issue date of May 18, 1954. The contract that Coates signed with the Tars stipulated that he be paid twice a month for his services during the 1954 season. The amount of $63.21 was his take-home pay. The check was signed by Tars president Earl Hagen and Roy Dessinger, the general manager of the team. (From the collection of Ron Pomfrey.)

MANAGER "SKEETER" SCALZI, 1954.
Frank John "Skeeter" Scalzi, a short,
stocky right-hander, broke into the
National League in 1939 with the
New York Giants and was used
sparingly as a shortstop and third
baseman. He only stayed for a quick
cup of coffee and played in a total of
eleven games during a brief big league
career. Scalzi spent the next 10 years
in and around the minor leagues and
ended up serving as player/manager
with the Portsmouth Cubs in 1949.
The following year he successfully
guided the Cubs to the pennant and
was awarded the league's Manager of
the Year award for his efforts. After
his successful 1950 campaign, he left
Portsmouth to oversee the second
division Lynchburg Cardinals for the
1951 season. In 1954, the Tars hired
Scalzi to manage the team and he
guided Norfolk to the league
pennant. (VP)

**BIG MOE THACKER TARS
CATCHER, 1954.** During the
1954 season, manager Skeeter
Scalzi could count on six-foot
three-inch Moe Thacker to
provide the necessary means to
handle his elite pitching corps.
During his brief stay with the Tars
Big Moe contributed to the team's
success by clubbing 9 home runs,
64 RBIs, and hitting a steady .264
at the plate. The Louisville,
Kentucky native eventually made
it to the majors with the Chicago
Cubs in 1958, and played a total
of five years in the National
League before hanging up his
spikes with the St. Louis Cardinals
in 1963. (VP.)

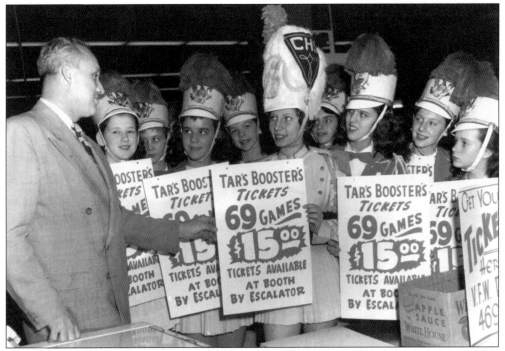

TRYING TO DRUM UP SALES FOR TARS TICKETS, 1955. In 1955, with Norfolk no longer able to count on the deep pockets of the New York Yankees to help with the bottom line, the local investment group that purchased the franchise began to languish under a financial crush to field and maintain a Class B minor league team. Promotions such as the event shown in the photograph above reflected some of the "cut-rate" methods the franchise took to convince the public to invest in the team. A Tars official offers some words of encouragement to a group of high school majorettes as they provided signs to distribute in a local department store. (NPL.)

THE LIGHTS GO OUT AT MYERS FIELD: FINAL GAME TICKET FOR THE NORFOLK TARS. With turmoil on the team and ambivalence in the stands, the Norfolk Tars played their final Piedmont League game at Myers Field on Wednesday July 13, 1955. The end came with a convincing 11–3 victory over the Sunbury Redlegs before a sparse and subdued crowd of 851 loyal fans. Norfolk pitcher Jerry Buchanan went the distance and limited the visitors to 10 hits as the Tars closed out their Piedmont League run with a record of 37 victories against 34 losses. At exactly 10:03 p.m. the lights at Myers Field were extinguished, almost 15 years to the day from when they were first illuminated in 1940. It would take another 15 years before professional baseball would return to the city of Norfolk. (CSTG.)

NORFOLK BASEBALL NOTES 1950–1955

♦ After being selected to serve as the starting center fielder for the 1951 Tars, Dorrel "Whitey" Herzog was informed by manager Mayo Smith that he was being demoted to the Joplin Miners of the Class C Western Association—after only a week in Norfolk pinstripes.

♦ Bill "Moose" Skowron played his first game as a Norfolk Tar on May 25, 1951, but not as a first baseman. He started his baseball career as a left fielder.

♦ During a May 17, 1953 game on the road against the Lynchburg Cardinals, Norfolk allowed 12 runs to cross the plate in a disastrous fourth inning. Manager Mickey Owen used five Tars pitchers in the top of the fourth with none able to throw a strike. When the inning was finally over, his five hurlers walked a total of 11 Cardinals, with 7 base on balls given up in a row. The evening ended in a 13–6 defeat for the Tars.

♦ On August 17, 1953, the Norfolk Tars lost to the Lynchburg Cardinals 3–0 in a game that lasted only one hour and 26 minutes.

♦ During the 1953 postseason Piedmont League playoff finals against Newport News, Tars manager Mickey Owen attacked Dodger pitcher and third base coach Owen Maguire as the sides were changing. During the melee Owen reportedly bit the ear of Maguire, and order was not restored on the field until police were called. Manager Owen was levied a $25 fine from the league with Maguire filing a $20,000 suit for damages to his ear. At a court hearing on March 4, 1954, in Hampton, Virginia the Tars's manager was found guilty of attacking the Newport News Dodger "without justification or provocation." The amount of the award was set at $2,500.

♦ The bonus awarded to each Norfolk Tar for capturing the 1953 Piedmont League pennant and the post-season playoff series was $165 per player.

♦ During a heated contest between Newport News and Norfolk in 1953, someone from the Dodgers dugout tossed a full bucket of water onto the playing field to protest a close call at the plate. The umpire walked over to the dugout and threw the suspected culprit out of the ballpark. It was the Dodgers batboy.

♦ During the waning days of the 1954 regular season, Tars president Earl Harper decided to stage a beauty contest for any interested local girls between the ages of 18 and 25. The event would be held at Myers Field before a scheduled game with the Lancaster Red Roses with the winner crowned "Miss Norfolk Tars of 1954." The prize was announced as an all-expenses-paid trip for two to New York City on National Airlines to watch the crowning of Miss America. On the night of the contest the Norfolk front office found themselves in a dilemma—only a single contestant showed up! Miss Sherry Morris of Westover Avenue arrived to the ballpark decked out in a one-piece bathing suit and high heels. Tars business manager Roy Dissinger, always willing to put on a show for the fans, recruited some "beauties" at the last minute and the contest began as scheduled. Along with Miss Morris, six members of the Tars, dressed in drag, sashayed in front of the Myers Field fans as part of the contest. Players Ozzie Grasso, Tom Venditelli, Jim Coates, Stan Rosenzweig, Danny Keith, and Bob Ruck did little to impress the crowd in their wigs, halter tops, and shorts. Despite the "tough" competition, Miss Morris won the event and was crowned the first (and last) "Miss Norfolk Tars."

♦ From 1934 until 1955, the Norfolk Tars won eight league pennants and captured five post season trophies. No other franchise during the entire history of the Piedmont League came close to the challenging Norfolk's winning tradition.

THE "CLOWN PRINCE OF BASEBALL" AND A NORFOLK FAN, 1988. Max Patkin, dubbed the "Clown Prince of Baseball," was a frequent visitor to Norfolk's Met Park for nearly 25 years. Patkin would entertain thousands of baseball fans each year with his slapstick style of entertainment that included serving as an inept Tides base coach, mimicking the visiting first baseman, and flashing outrageous and hilarious signs to confused batters during the game. A fan favorite at baseball venues everywhere, the legendary Patkin performed in over 4,000 consecutive minor league engagements before his retirement in 1996. Shown here in his trademark baggy uniform and flashing a rubber-faced grin, the "Clown Prince" poses with young fan, Andrew Garrett, before a Tides game at Norfolk's Met Park in 1988. (CSTG.)

NINE

Baseball . . .

For the Fun of It

The reason for the popularity of baseball is often debated among its fans and critics. Why is America in love with this simple game? The answer can be as varied and complex as the men, women, boys, and girls that watch, play, analyze, and criticize the sport. While baseball is most often sensationalized by the media and worshipped by fans at the professional level, one can still easily find the simple roots of the game in communities and neighborhoods across America. Baseball continues to be a colorful montage created by hometown children and the young at heart. The true easel of the game may be best represented as a field bordered by ragged chain link fence and adorned with swatches of coarse, wooden bleachers worn smooth by nervous parents on countless Saturday mornings.

So why is America in love with this simple game? Maybe the answer should come from the younger generations that play and watch rather than from the talking heads and sports analysts on television. Ask any of the thousands of boys and girls that set their alarm for the pre-dawn hours on the day of their first ball game and then wake in anticipation well before the ringer strikes. Ask the high school pitcher that strides through the locker room in a confident cadence to the rhythmic clicking of his spikes as his fingers itch with anticipation for the first pitch of the game. Ask the young rookie stepping into a major league park for the first time to realize that this moment is no longer a dream. All will say that baseball is more than a game and nothing less than a feeling of pleasure, joy, and fun—simple feelings elicited from a simple game.

Spring begins a time-honored tradition throughout the city of Norfolk. Along with the eruption of daffodils and the crowning of the first new blades of fescue through soil, come the sound of rakes, shovels, and hoes—all the necessary instruments that bring a baseball diamond back to life. After months of cold neglect, the baselines are redrawn, dirt is spread, weeds are pulled, and fences are repaired. The field, like nature, is reborn in spring and the children of Norfolk are itching to roll, tumble, run, and slide in all its glory. From the historic neighborhoods of Ghent and Colonial Place, along the sands of Ocean View, to the expansive fields bordering Riverview and the city park, children will come and play. It has happened every year for over a century beginning in the late days of March and running nonstop like a child scampering swiftly around the bases until the weather forces the bat, ball, and glove to the bedroom closet for a much-needed hibernation.

Look upon the faces of the photographs in this chapter. The love of the game is reflected in the smiles of fans laughing at the antics of baseball clowns such as Max Patkin and Al Schacht. Discern the unbridled pleasure emanating from the boys holding tickets to the first game of the season. See the posed innocence of the 1934 Generals, a group of friends pulled together in a photographic moment because of baseball. Even the need for consistency and routine is reflected by the use of the scoreboard that once graced busy Brambleton Avenue for Norfolk fans to keep in touch with the progress of their team during the working day.

Flip through the pages in this chapter and reflect upon your own memories of the game and enjoy baseball . . . for the fun of it.

TAKE ME OUT TO THE BALL GAME. Pictured here in this candid image is a group of boys showing off their most prized possession to the photographer . . . a ticket that will allow them to pass through the Bain Field turnstile and enjoy a day of baseball watching the Norfolk Tars. Judging from the knickers the boys are wearing it appears this photograph was taken in the mid-1930s. (CSTG.)

A BOY AND HIS DOG. This young boy brought along his dog to watch late afternoon batting practice at Myers Field on a warm fall day in 1950. Both seem to be quite interested as players prepared for a Piedmont League match at the ballpark. (NPL.)

THE LOUISVILLE SLUGGER. During a sports equipment trade show held at the Municipal Center in Norfolk during the winter of 1950, a representative for Louisville Slugger bats shows a special model to a timid, young baseball fan. The exhibit showcased actual player's game-used bats and featured the lumber once used by Lou Gehrig, "Pop" Anson, Tris Speaker, and Honus Wagner. This youngster is being shown a bat used by the legendary Babe Ruth but does not appear impressed with its historical significance. (NPL.)

A NEW SCOREBOARD FOR NORFOLK BASEBALL FANS, 1938. In May 1938, the *Ledger-Dispatch* placed a new baseball scoreboard that was "bigger, better, and more complete" on busy Brambleton Avenue next to the newspaper's office building. The scoreboard was designed to post inning-by-inning updates of National, American, and Piedmont League games for interested pedestrians and fans passing by in automobiles. In this image, a worker posts the latest results from the diamonds as they are received over the wire by the newspaper's sports department. (NPL.)

BASEBALL'S ORIGINAL CLOWN PRINCE. Before there was Max Patkin, there was Al Schacht, the original "Clown Prince of Baseball." Schacht started his baseball career as a pitcher with the Washington Senators and posted 14 victories from 1919 through 1921. His extensive traveling brought him to Norfolk for numerous engagements, as evidenced by this photograph taken while clowning at Bain Field in the 1930s. (NPL.)

DONKEY BASEBALL COMES TO NORFOLK. Three local businessmen prepare to take the field at High Rock Park to participate in a special pre-game contest of baseball . . . played while riding donkeys. The game always brought the fans out to the park early and provided plenty of opportunity to begin the night with a good laugh. The authors cannot be sure, but it appears that all three of the donkeys pictured here were catchers, judging from the condition of their knees. (NPL.)

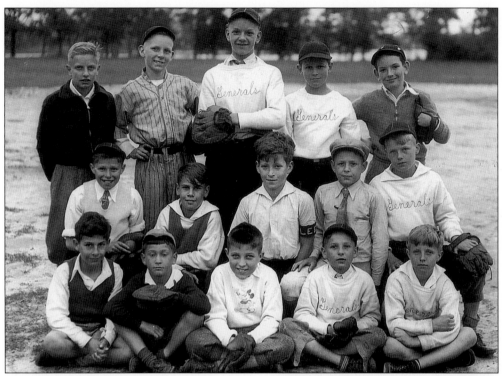

THE BOYS OF SUMMER: THE LEE GENERALS BASEBALL TEAM OF GHENT, 1934. With its community leagues, Little Leagues, American Legions, and high schools, Norfolk has had a long history of supporting youth baseball. Shown in this vintage image is a local team of boys attending Robert E. Lee Elementary School, located on Moran Avenue in the city's Ghent neighborhood. With some wearing shirts proclaiming themselves as the "Generals" of Robert E. Lee, the boys pose somewhat reluctantly for the photographer, surely anticipating the final click of the shutter so they can grab bat, ball, and glove and begin another spirited game. (NPL.)

THE GIRL CAN PLAY, 1950. Throughout the city, teams of youngsters took their positions on any number of Norfolk diamonds from Ocean View, to Larchmont, to Norview. One such player was Carol Kaufman, a young girl in a pigtail and blue jeans who could throw a mean fastball past opposing batters. In this candid picture, Carol is shown giving some unheeded advice to her older brother on the mechanics of an effective pitching grip. (NPL.)

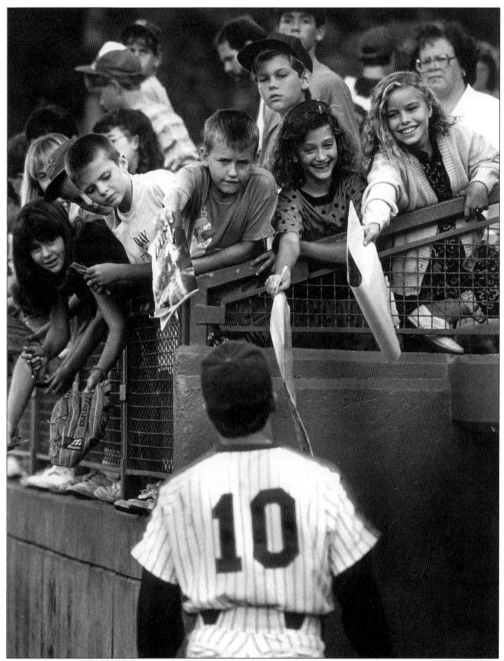

GETTING AN AUTOGRAPH IS A JOYFUL . . . YET QUITE SERIOUS BUSINESS. It appears from the standpoint of this 1990 photograph that there are two different techniques in acquiring an autograph at Met Park in Norfolk. For the two girls in the top right of the picture, it would seem that a radiant smile and a long arm would do the trick. However, for the boys closer to the field, the need to wear the seriousness of their request on their faces is evident. In either case the different methods must have proven successful since Tidewater Tides player Mike DeButch (#10) soon obliged all requests and signed posters, gloves, cards, and programs for the young fans. (VP.)

114

TEN

A New Era Begins and Continues with the Tides

When the lights at old Myers Field were extinguished on the evening of July 13, 1955, Norfolk fans drove home not knowing how the future of baseball would unfold in their city. By 1957, the ballpark sitting at the corner of Church and Rugby Streets was in sad disrepair with further insult provided by a fire that blackened the bleachers and made the park unusable for even amateur teams. Not long afterwards, the charred bleachers were dismantled, the press box torn from its supports atop the grandstands, and the turnstiles pulled from their foundations and taken to the city dump for a final, undignified burial. Baseball was indeed gone from the city and nothing drove the truth home more than the demolition of Myers Field.

Across the Elizabeth River, in the city of Portsmouth, the grand concrete edifice of Portsmouth Stadium saw the Merrimacs finish out the 1955 Piedmont League season, but then lose its franchise when the league folded. Portsmouth Stadium stood its ground over the next several years and continued to serve the city during football season, but saw only limited play on the diamond with no minor league teams giving the city and its facility a second look. By 1960 Portsmouth had staged a few exhibition games at the stadium with good interest shown by the number of fans that attended. Soon there was talk among the media that a group of investors had surfaced and appeared serious in bringing baseball back to the area. In April of 1961, a new baseball club took up residence in Portsmouth as members of the Class C South Atlantic League under the ownership of William McDonald of Miami.

The naming of the team was to be left in the hands of the readers of the local paper, the Virginian-Pilot. After a lengthy selection process, the name "Mariners" won out but was eliminated by editor Robert Mason in favor of the "Tides" because of its alliteration with Tidewater. With former Philadelphia Phillies "Whiz Kid" Granny Hamner selected as the inaugural skipper for the newly formed franchise, the Tides finished deep in the league's second division but drew a respectable 87,158 fans to the stadium. In 1962 the Portsmouth-Norfolk Tides became affiliated with the St. Louis Cardinals organization, who offered players and financial support.

By 1963, the "Sally" League decided to set the Virginia teams free because of travel restrictions. The possibility of the city losing its team seemed eminent until Dave Rosenfield, assistant general manager in 1962, formed a local group to save the team and gain entrance into the Carolina League. For the next six years the team would struggle under the sponsorship of the Chicago White Sox and the Philadelphia Phillies until 1968. In 1969 the New York Mets decided to move their AAA International League franchise from Jacksonville, Florida to Tidewater. In their first year under the Mets banner, the Tides won the league pennant with former major leaguer Clyde McCullough at the helm.

With help from the parent club and substantial funding through the city of Norfolk, the new

Metropolitan Park was constructed in time for the opening of the 1970 season. It was a state-of-the-art facility with seating for 6,200 and a restaurant overlooking the infield from behind home plate. It took Norfolk almost 15 years to get baseball back within the city limits and the success at the gate was immediate. While drawing only 67,292 at the old Portsmouth Stadium in 1969, the Tides doubled attendance figures by the end of the season as 142,290 patrons passed through the turnstiles.

The stadium was a hit with fans as they witnessed several Tides championships over the years. The franchise was awarded the International League's Governor's Cup in 1972, 1975, 1982, 1983, and again in 1985. To top it off, the Tides went all the way to the Triple-A World Series and won the event in 1983.

Key players came and went through the area on their way to major league stardom with the Mets and other National and American League teams. Players such as Ken Singleton, Rick Aguilera, Ron Allen, Wally Backman, Hubie Brooks, Buzz Capra, Kelvin Chapman, Ron Darling, Lenny Dykstra, Gil Flores, Dwight Gooden, Randy Milligan, John Gibbons, and Greg Jefferies first made a name for themselves as Tides at Norfolk's Met Park in the 1970s and 1980s.

As the franchise entered the 1990s, it was evident that the small seating capacity of Met Park was keeping the Tides's attendance figures at or near the bottom of the league. It was only a matter of time before a new, larger facility would have to be constructed to house the team into the next century. In February 1992, ground was broken on the banks of the Elizabeth River for a new stadium that would be christened Harbor Park. During this same period the ownership of the Tides transferred to a group of Florida businessmen headed by Ken Young. With the new stadium came a new name for the team—the Norfolk Tides. The name was selected in order to help garner a more familiar national geographic identity for the team and the franchise.

A banner year was had by the Tides in 1993 as fans busted down the gates to see ballgames at the most beautiful minor league ballpark in the country. Over 555,000 fans enjoyed many afternoons and evenings of entertaining baseball and comfortable accommodations. This was also the year that General Manager Dave Rosenfield would claim his fourth International League Executive of the Year Award. To top it off, the team was awarded the John H. Johnson President's Trophy from the National Association of Professional Baseball Leagues. This prestigious award is given to baseball's most complete franchise from top to bottom, in regard to history, commitment to the community, and financial success.

As the 2002 season drew to an end, the Norfolk Tides completed another page in their rich history by providing the city a winning baseball team, a professional and respected franchise, and a first-class venue for the fans. As the players, fans, and administration look forward to the future, the city can rest assured that the Tides will supply all the necessary elements for many years of baseball in Norfolk, Virginia.

METROPOLITAN MEMORIAL PARK

THIS PARK IS DEDICATED IN SINCERE TRIBUTE TO THE LIVING AND DEAD WHOSE VALIANT EFFORTS AND UNSELFISH SACRIFICES HAVE MADE AMERICA GREAT. GOD GRANT THAT THE LIBERTY OF HUMANITY WON ONLY BY BRAVE SOULS AND VIGILANT GUARDING SHALL LIVE ON WITH INCREASED STRENGTH AND SPIRIT PERPETUATED FOR ALL AGES TO COME. MORE LASTING THAN WORDS MORE GLORIOUS THAN PRAISE IS OUR GRATITUDE FOR THEIR GREAT UNSELFISHNESS.

METROPOLITAN PARK PLAQUE, 1970. This plaque once graced the central grandstand wall on the outer concourse of Norfolk's Metropolitan Park. The stadium was dedicated to the military veterans of the country and served as the home field for the Tidewater Tides from 1970 until 1992. (VP.)

KEN SINGLETON, 1970. Posing in front of an unfinished portion of Norfolk's new Metropolitan Park is 22-year-old Ken Singleton. The Tides rookie spent the early months of the 1970 season in Tidewater, appearing in 64 games, hitting an impressive .388 from the plate. He was called up to the Mets during the summer and soon found himself patrolling the outfield grass at Shea Stadium. Singleton served 15 years in the major leagues with his most productive seasons coming with the Baltimore Orioles. (NTBC.)

JON MATLACK, 1969–1971. Jonathan Trumpbour Matlack first appeared in a Tidewater Tides uniform while the team was finishing their final (1969) season at Frank D. Lawrence Stadium in Portsmouth. A mainstay with the Tides from 1969 until the Mets called him up late in the 1971 season, he posted winning records in each of his seasons with Tidewater and struck out over 100 batters each year as well. In 1972, Matlack would win the National League "Rookie of the Year" award with an ERA 2.32. During a 13-year major league career with the Mets and Texas Rangers, he won a total of 125 games and kept his ERA at a respectable 3.18. (NTBC.)

HANK BAUER AND BILLY SCRIPTURE, 1971. Hank Bauer, the new manager for the Tidewater Tides in 1971, looks over a line-up card with his player-coach Bill Scripture before a game at Norfolk's Met Park. Bauer would serve as skipper for the Tides in 1971 and again in 1972, completing both International League seasons with winning records and first division finishes. A fourteen-year major league veteran with the New York Yankees and the Kansas City Athletics, Bauer retired as a player in 1961 with a .277 average and 164 home runs to his credit. Before coming to the Tides in 1971, he served as manager for the Athletics and Orioles and took Baltimore to the World Championship in 1966. (NTBC.)

LATE WITH THE TAG AT HOME, 1975. Tidewater Tides catcher Ron Hodges applies a late tag to Memphis Blues player Jerry White in the fourth inning of a contest at Met Park during the 1975 season. Umpire Steve Fields has a close eye on the play and is ready to call the runner safe. Ron Hodges appeared in 95 games for the Tides in 1975, as the team would capture the pennant in the International League and the Governor's Cup trophy by winning the post-season playoffs. Tides manager Joe Frazier was named top skipper of the league for guiding the Tides through a successful season. (VP.)

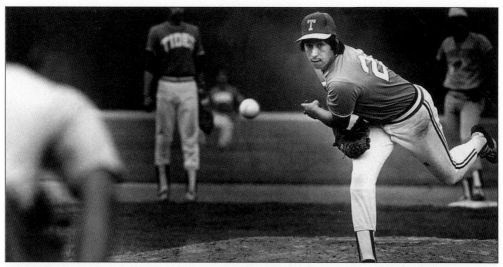

TIDES FIREMAN JESSE OROSCO, 1979. Pictured here after releasing a warm-up pitch from the mound at Met Park in 1979 is relief specialist Jesse Orosco. Used primarily as the fireman out of the bullpen, Orosco appeared with the Tides in 1979 and again in 1981. In a long major league career he has pitched for a number of teams and was selected to the National League All-Star team in 1983 and 1984 while with the New York Mets. During the winter of 2002 Orosco signed a contract with the San Diego Padres, making that his 24th year in the major leagues. (VP.)

TIDES PITCHING ACE MIKE SCOTT, 1977–1980. Few pitchers spent as many years in a Tides uniform as did Mike Scott. For parts of four seasons beginning in 1977, Scott was one of the most successful hurlers for the Tides, with a career record of 31 victories and 22 defeats. He was the workhorse of the Tides staff in 1978 and still holds the club record with most games started (29). Scott finally made it up to the Mets for short visits beginning in 1979 but proved to be less than effective on the mound. His luck changed when he was traded to the Houston Astros and developed the split-finger fastball under the guidance of former major league pitcher Roger Craig. He suddenly became un-hittable and posted dominating statistics from 1985 through 1989. His best season came in 1986 when he won 18 games while leading the league in strikeouts (306) and ERA (2.22). For his accomplishments on the mound, Scott won the 1986 National League Cy Young award. (NTBC.)

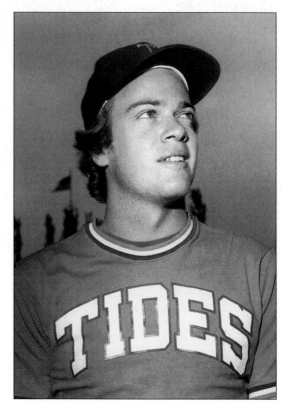

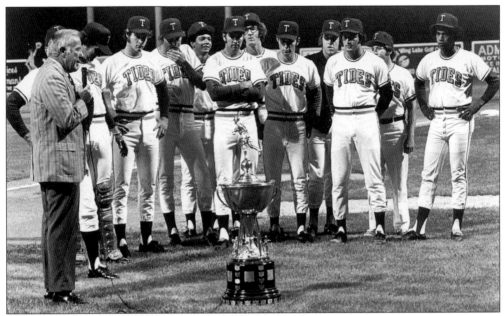

INTERNATIONAL LEAGUE TIDEWATER TIDES RECEIVE THE GOVERNOR'S CUP, 1975. In 1975 the Tidewater Tides dominated the International League by capturing the pennant with an 86–55 record and then eliminating all contenders during the postseason to capture their second Governor's Cup trophy in the history of the franchise. At the microphone making the presentation is Tides President Dick Davis. Manager Joe Frazier and his team admire the trophy that would be displayed at Met Park during the 1976 season. (VP.)

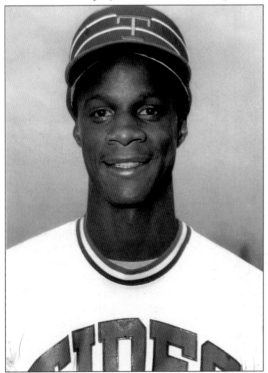

DARRYL STRAWBERRY, 1983. While only appearing in 16 games as a Tidewater Tide, Darryl Strawberry left quite an impression with local fans as he rushed through Norfolk on his way to Shea Stadium. During the first month of the 1983 International League season, Strawberry hit .333 and stroked 3 home runs. During his eight-year tenure with the New York Mets, he would set team records in home runs, RBIs, and extra base hits. He served 17 years in the major leagues and was named Rookie of the Year in the National League in his first year with the Mets. His career yielded 335 home runs and he was named to the All-Star team eight times. (NTBC.)

KEVIN MITCHELL, 1984. Used primarily as the third baseman for the Tides, Kevin Mitchell served two seasons in Norfolk before his call up to the Mets in late 1985. Known for his solid defense, he led International League third basemen with 215 assists during the 1984 season. In 1986 Mitchell played a key role in the Mets championship season by playing six different positions and hitting a solid .277 from the plate. Mitchell's major league career lasted 13 years and he was honored as an All-Star twice during that span. He led the National League in home runs (39) while with the San Francisco Giants in 1988. (NTBC.)

LENNY DYKSTRA, 1985. As a Tidewater Tide in 1985, Lenny Dykstra appeared in 58 games and scored 44 runs with a solid .310 batting average. Nicknamed "Nails" for his toughness on the field, the 22-year-old Dykstra earned a spot with the Mets after his brief stay in Norfolk and served at the major league level for 12 seasons with New York and Philadelphia. Known for his hard-nosed style of play, Dykstra always seemed to have the dirtiest uniform on the Tides when the game ended. He had his finest season in 1993 when as a member of the Philadelphia Phillies he led the National League in hits, walks, and runs scored. His major league career is highlighted with three All-Star game appearances. (NTBC.)

TIDES MANAGER BOB SCHAEFER IS PRESENTED THE GOVERNOR'S CUP TROPHY, 1985.
Despite finishing the 1985 International League season in a tie for third, the Tides managed to
excel in the postseason and ended up capturing their fourth Governor's Cup in 1985. In the
semi-final series of the playoffs they defeated the Maine Guides three games to two and
eliminated the Columbus Clippers in four games to earn the trophy. Shown here presenting the
historic Governor's Cup to Tides manager Bob Schaefer is Mike Tamburro, general manager of
last year's champs, the Pawtucket Red Sox. Jubilation spread throughout the stadium and field,
evidenced by pitching coach John Cumberland's victorious salute as he leads Steve Springer
and his fellow Tides teammates in a celebratory cheer. (VP.)

MOOKIE WILSON, 1979. William
Hayward "Mookie" Wilson first
donned a Tidewater Tides uniform
in the Spring of 1979 and
immediately was a fan favorite for
his solid defensive skills in the
outfield and his speed on the base
paths. Mookie often proved to be
the catalyst that ignited a Tides
uprising just when it was needed.
He returned to the Tides in 1980
and was called up by the Mets late
in the season. He returned to
Tidewater in 1986 for 9 games as
part of a rehabilitation assignment.
He holds the Tides's (AAA) single
season record for most triples (14)
and stolen bases (50), both
accomplished during the 1980
season. Mookie served 12 seasons
at the major league level before his
retirement as a player. (VP.)

SHORTSTOP KEVIN ELSTER, 1987. A confident 19-year-old Kevin Elster poses for a publicity shot as a new member of the Tidewater Tides in 1987. Elster had a short sip of coffee at the major league level with the Mets in 1986 but would prove his worth in Tidewater with a solid year at the plate and in the field for the 1987 season. During 134 games, Elster maintained a .310 batting average and knocked in 74 RBIs. His 170 hits and 549 at-bats in 1987 are still Tidewater (AAA) single-season records. His major league career spanned 15 seasons with a variety of teams, including the Mets, Yankees, Phillies, Rangers, Pirates, and Dodgers. Elster dabbled in acting with a role as shortstop Pat Corning in the 1994 movie *Little Big League*. (NTBC.)

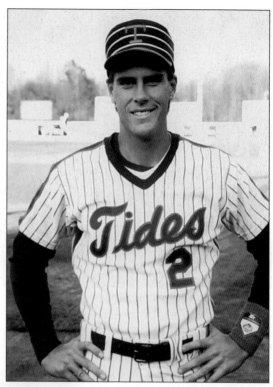

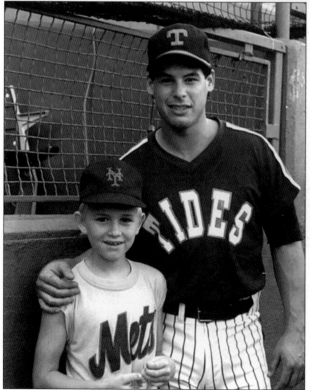

GREG JEFFERIES AND FAN, 1988. Posing here with young fan Andrew Garrett is one of the most popular Tides of all time: Greg Jefferies. The 19-year-old infielder spent the 1988 season with Tidewater and had a banner year with 142 hits and a .282 batting average and still holds the Tides record for the longest hitting streak (24). Jefferies played 14 years in the majors and was selected to the national League All-Star team in 1993 and 1994. His .342 batting average in 1993 with the St. Louis Cardinals ranked among league leaders. In 1995 Jefferies signed a 4-year, $20 million free agent deal with Philadelphia and later retired from baseball in 2000 as a Detroit Tiger. (CSTG.)

DAVE ROSENFIELD, GENERAL MANAGER. Known for his knowledge and experience as general manager for the Tides, Dave Rosenfield has served in the front offices of professional baseball since 1956, when he began as administrator for the Bakersfield Boosters of the Class C California League. Dave took over the role of general manager when the Tides toiled in Portsmouth during the 1962 season as part of the Class A South Atlantic League. His accomplishments with the Tides are many and include winning the International League "Executive of the Year" four times over his storied career. (NTBC.)

KEN YOUNG, NORFOLK TIDES PRESIDENT. Tides President Ken Young displays the new uniform his team will wear since the franchise changed its name from "Tidewater" to "Norfolk" in the spring of 1993. Young was involved with negotiations for concessions at the new ballpark and decided to expand his offer for the team and put together a group of investors to buy the Tides. His leadership has resulted in improved attendance at the gate, with the team averaging at or near the 500,000 mark since 1993. Young is an easily approached owner and is often seen sitting and talking with fans before, during, and after games at the park. (VP.)

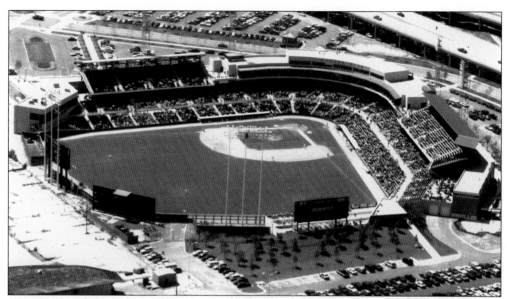

HARBOR PARK, NORFOLK'S DOWNTOWN DIAMOND, 1993. Shown here from the air is Norfolk's beautiful Harbor Park. The facility was christened on the evening of April 14, 1993 as the Norfolk Tides shut out the Ottawa Lynx 2–0 in front of a sold-out crowd. Harbor Park was designed by HOK Sport Facilities Group, the same organization that laid the plans for Baltimore's Oriole Park at Camden Yards and Jacobs Field in Cleveland. Seating capacity is 12,067 with 24 luxury skyboxes and a 250-seat restaurant that offers spectacular views of the game from right field. In 1995, *Baseball America* selected Norfolk's Harbor Park as the finest minor league facility in the country. (NTBC.)

JASON ISRINGHAUSEN, 1995. The 23-year-old right hander looks intently toward the plate and prepares to fire his fastball to an opposing batter during a game at Norfolk's Harbor Park. Isringhausen first joined the Tides in 1995 and posted a 9–1 record with an impressive 1.55 ERA. He was called up to the New York Mets midway through the season and continued his winning ways, finishing his first year in the majors with a respectable 9–2 record. For his accomplishments with the Tides, he was named International League Pitcher of the year in 1995. Since moving on to Oakland and St. Louis at the major league level, Isringhausen has developed into an effective closer and finished the 2002 season with 32 saves. (NTBC.)

BOBBY VALENTINE, TIDES MANAGER, 1994 AND 1996. With the grandstands of Harbor Park behind him, Norfolk Tides manager Bobby Valentine smiles into the camera's lens while leaning against the dugout railing in this 1996 picture. Valentine first served as skipper for the Tides in 1994 but could only lead the team to a fourth-place finish. During his second tenure as Tides manager, Valentine was called up by the Mets on August 26, 1996 to replace Dallas Green at the helm for New York. His playing career in the majors saw him on the roster of five different teams and used in almost every position including the outfield, all four infield positions, and as catcher for two games with the Seattle Mariners in 1979. (VP.)

THE 2002 NORFOLK TIDES. Manager Bobby Floyd (front row center) and his 2002 Norfolk Tides pose for their team picture on a sunny day in the stands of Harbor Park. The team would fashion a 70–73 record, earning them a third-place finish in the Southern Division of the International League. Norfolk Tide Marco Scutaro was selected to the league's All-Star team as the starting second baseman and hit a solid .316 over the 2002 season. (NTBC.)

NORFOLK TIDES BASEBALL NOTES

- The most potent hitting team of all time for the Tides during their International League years was in 1969 when they batted a record .283 during the 136 game season.
- Sid Fernandez struck out 17 Maine Guides in a game at Met Park on May 7, 1984 to set a Tides individual game record. He repeated the feat almost a year later against the Pawtucket Red Sox on May 2, 1985.
- During the 1987 season, no one could top the accomplishments of Tidewater Tides first baseman Randy Milligan. He was selected to the International League All-Star team, named league MVP, "Rookie of the Year," and "Minor League Player of the Year."
- On May 13, 1988, Phil Lombardi had the most productive game ever for the Tides as he knocked in eight runs during a game in Rochester.
- Tidewater Tides pitcher Dave West set the franchise single-season record for the lowest ERA by only giving up an average of 1.80 runs per nine innings.
- In 1992, one of the worst years in the history of the franchise, the Tides lost a record 86 games and finished 38 games behind the division winner. During a scheduled eight-game home series in mid-August, the team was unable to play any of its contests due to torrential rains that hit the Tidewater area.
- The first game played at Harbor Park, Norfolk's new riverfront stadium, resulted in a 2–0 victory for the Tides on April 14, 1993. Bobby Jones started the game for the Tides and gave up the first hit in the new ballpark to Ottawa Lynx player Terrel Hansen, a former Tide.
- The Tides were without a formal mascot until March 10, 1993, when "Riptide," the team's big, blue, fuzzy creature, was "hatched" at the Norfolk Scope in front of 7,000 fans attending a local hockey game. Always a favorite, "Rip" speeds around Harbor Park on his four-wheeler, signs autographs, and races children around the base paths between innings of each game.
- No other Tides player stepped to the plate more often at Met Park or Harbor Park than Steve Springer. In his six-year career with the Tides, he holds the record for at-bats with 2,635. He also holds the franchise career record in doubles (115), RBIs (320), runs scored (326), strikeouts (459), games played (720), hits (717), and total bases (1,015). Appropriately, Springer was also the first Norfolk Tides player to take his place in the batter's box at Harbor Park on April 14, 1993. He stroked a double to the outfield wall.
- On August 31, 1996, Harbor Park set an all-time attendance record as a standing-room-only crowd of 14,263 fans crammed the stadium to see the Tides take on the visiting Richmond Braves. Seating capacity for the park is listed as 12,067.
- During the 1998 campaign, Norfolk Tide Todd Haney set the single season record for highest batting average by hitting .345 from the plate.
- The most humiliating defeat for the Tides came on June 4, 1999 when they were manhandled by the Pawtucket Red Sox on the road 25–2.
- Located on the walls lining the concourse of Harbor Park is the Tidewater Baseball Shrine. It honors local stars of the diamond and key players that once played in the area with a plaque and information regarding their careers. A partial list of inductees includes Yogi Berra, Bob Feller, Allen Gettel, Bill "Moose" Skowron, Tommy Holmes, "Catfish" Hunter, Harry Land, Bud Metheny, "Ace" Parker, Hack Wilson, and "Pie" Traynor.

ABOUT THE AUTHORS

Clay Shampoe and Tom Garrett consider themselves archaeologists on a quest to research local sports history of the Hampton Roads area of Virginia. Their mutual journey in the creation of this book goes back many years. It is a culmination of shared interests that began with the gathering of local memorabilia and developed into a desire to learn as much as possible about the history of baseball in Norfolk.

Tom is a retired special education principal who served in the Portsmouth Public Schools for three decades. Clay Shampoe is a speech-language pathologist at Children's Hospital of The King's Daughters in Norfolk. Their working relationship is only exceeded by the deep friendship and respect they share for one another. Future books are in the planning stages that will explore baseball in Portsmouth, Virginia, the history of the Norfolk Tides, the rise and fall of the Virginia Squires, and football history in the Tidewater area. Tom (left) and Clay (right) are pictured during a research visit to the National Baseball Hall of Fame Library in Cooperstown, New York. (Photograph by Jim Shampoe.)

BIBLIOGRAPHY

Chrisman, David F. *The History of the Piedmont League*. Bend, Oregon: Maverick Publications, 1986.

Chrisman, David F. *The History of the Virginia League*. Bend, Oregon: Maverick Publications, 1988.

Clark, Dick and Larry Lester. *The Negro Leagues Book*. Cleveland: The Society for American Baseball Research, 1994.

Filichia, Peter. *Professional Baseball Franchises*. New York: Facts On File, Inc., 1993.

Johnson, Lloyd and Miles Wolff, Editors. *The Encyclopedia of Minor League Baseball (2nd Edition)*. Durham: Baseball America, Inc., 1997.

Light, Jonathan Frazier. *The Cultural Encyclopedia of Baseball*. Jefferson, North Carolina and London: McFarland & Company, Inc., 1997.

Reichler, Joseph L., Editor. *The Baseball Encyclopedia (7th Edition)*. New York: Macmillan Publishing, 1988.

Riley, James A. *The Biographical Encyclopedia of the Negro Baseball Leagues*. New York: Carroll and Graf Publishers, Inc., 1994.